jam style + music + media

edit: jane alison+liz farrelly
text: jane alison, liz farrelly, james pretlove+
claude grunitzky
book design: sophia wood+fabian monheim at fly

project idea: jane alison
working group: jane alison, steven armstrong, lucy
brettell, tom dixon, liz farrelly, alan king,
beverley luckings, michael oliveira-salac
+james pretlove, blow

the exhibition is supported by: dataton ab, medite, chris moore,
philips media, planet fashion, rough
trade records, rushes, the spot company

jam style + music + media

these are
some very fine
girls and
boys

contributors:anette aurell, anti-rom, antoni & alison, durrell bishop,
matt black, blue source, mark borthwick, brian of britain,
buggy g riphead, captain 3d, hussein chalayan, anna cockburn,
fly, simon foxton, fuel, stephen fuller, nick griffiths, header,
hex, nick knight, phil knott, alexander mcqueen, donald milne,
annett monheim, jeremy murch, ninja tune, obsolete,
jessica ogden, rankin, david sims, tomato, trip media et mr...

forever hopeful (antoni & ali
let your guard down, but be a
every opportunity. in short, m
try not to fuck people over, hav
(james pretlove, blow). fluid wi
carefree (simon foxton). zealo
beginning (tomas roope, anti-r
polaine, anti-rom). varied (anna
(brian of britain). be positive,
the best (liz farrelly). dealin
smooth as sofa - lay ha

virtually
fat free

on). the code of the streets...never
are that life is too short not to seize
ke it happen (claude grunitzky, true).
a good time, move forward constantly
some bumpy bits (buggy g riphead).
s over confident (rankin). start at the
). love and honesty, man (andy
cockburn). passionate and frustrated
t it happen and it will, and usually for
with the rough as tough and the
and listen to the sound! (nick
griffiths).

Q:how would you describe your attitude to life

A:

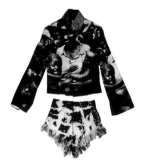

design:**alexander mcqueen**
autumn/winter 1996

introduction

A snapshot of '90s urban style culture, JAM presents a cut and paste mix of still and moving images, clothes, music and new interactive media. Intentionally unorthodox, JAM is neither art historical, anthropological nor deliberately instructive. And although it is selected, JAM is not driven by established or academic taste. Instead, JAM seeks to give a platform to a diversity of creative people working outside the fine art arena, chosen for their empowering attitudes, a contemporary non-retro approach to image making, with 'sampledelia' - an eclectic spirit - often the defining characteristic. Just one example...Fashion designer Alexander McQueen manages to combine, within one collection - his most recent and rightly acclaimed - the aesthetics of ceremonia and trash, with experiments intailoring and the over-printing of photo-reportage images from war zones and the like.

JAM artists are making work within the style-music-media interface that is not only the most innovative and challenging of its kind, but is also, for the most part, accessible and unpretentious. That JAM is happening at all is a reflection that the established art world is sitting up and taking note. Forget Cork Street, even Goldsmiths, the style and music arena is - for the first time since the '60s - where the excitement is really happening.

I am grateful to Rankin, the driving force behind Dazed and Confused, for planting in my head the notion of a 'walk in magazine' as it seems to describe quite well what JAM sets out to be. Without being restricted to a page format, magazine ingredients can be mixed up, scaled up and literally brought to life to be experienced in a completely new way.

No surprise then that the photographers, fashion designers, and stylists in JAM tend to be associated in one way or another, depending on their various allegiances, with the

mafioso of style mags; The Face and i-D, or the younger upstarts like Dazed and Confused, True, Blow and Experiment. These, plus a wealth of others across both style and music subjects and some which defy categorisation - from photocopied fanzines to slick new glossies - mark a burgeoning of creativity in the magazine publishing world. Their content mirrors the entire spectrum of alternative art production from underground and DIY-culture projects ranged around clubs, festivals and protests, to major commercial ad campaigns.

As if by way of a tribute, and as a preface to what follows, JAM begins with the mainstay of the style mag: the collective fictions and subversions of the photographer/stylist partnerships - Knight/Foxton, Sims/Cockburn and Aurell/Monheim. These same stylists are among those at the forefront of promoting young British design talent, and in JAM we feature McQueen, Chalayan, Ogden, Fuller and Brian of Britain. Each of these designers, whilst bringing their own unique intelligence and imagination to the art of designing and making clothes, is in the process, whether actual or constructed via the style industry, of identification and interaction with the street. Which is where JAM widens to embrace the single most important ingredient that sets it apart from anything which has gone before; the inclusion of new popular and cutting-edge music, the pulse of urban style culture. As Claude Gruntizky, the editor of True magazine, concurs in this book, music is once again at the very heart of a regeneration in our creative culture. And so JAM punctures the pseudo-religiosity of the hallowed white cube approach to exhibition making with a celebration of dance floor and experimental beatz from, amongst others, DJ Food and Underworld.

If the magazine is the traditional vehicle for a cut and paste aesthetic, and with music in the midst of a DJ/DIY-instigated

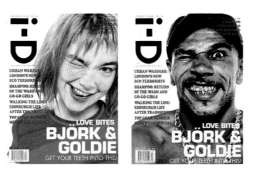

artist:**muslimgauze** title:**nadir of purdah** label:**jara discs** design:**mark crumby** 1995

title:**i-d** editor in chief:**terry jones** art direction:**scott king** photograph:**lorenzo agius** 1996

sampling revolution, the computer offers a parallel and frequently overlapping culture. It is in this new visual domain that the likes of Anti-Rom, Header, Hex and Buggy G Riphead are exploring the mutations described by Liz Farrelly in her contribution which follows.

Whether it is Buggy's computer-manipulated mindscapes for Future Sound of London, Tomato's elegant constructions in type for Underworld, Donald Christie and Trevor Jackson's gritty monochromatic realism for rap and hip hop label Bite It, or the Ben Drury/Futura 2000 combo for Mo Wax, sleeve art is the vehicle where all the JAM ingredients fuse; music, icons, ideas, computer-manipulated imagery, graphics, art direction and photography. The 12" cover is a JAM talisman and signpost. Each music and dance oriented subculture is identified, if not delineated and coded by them. Within the forest of covers arranged by the exhibition's designer, Tom Dixon, it is possible to find yourself, and in the incantation, 'I've got that', feel yourself to be part of the whole.

Many music producers are, unlike the graphic designers who promote and package them, oblivious to the concerns of the style avant-garde. However, exceptions, like those icons of style and musicianship Björk and Goldie, serve to remind us that music and style are never far apart. On the cover of Post - sleeve design by leading computer imagists Me Company - Björk wears a jacket by Hussein Chalayan whilst Goldie struts his stuff on McQueen's catwalk. On another level, the stylist/photographer partnership of Nick Griffiths and Jeremy Murch chart the subtle nuances of tribal dress codes in street and club culture. As Nick Griffiths simply states, 'how you listen' is, at street level at any rate, 'how you look'.

Our intention was, from the first, to make JAM as much about the personalities and ideas behind the work as it was about the

work itself. To this end we asked participating artists to fill in a questionnaire and send us a candid photo. And so it is that this book is greatly enriched by a compendium of aspirations, ideas and, well, just plain nonsense!

This rogues gallery approach is very much in keeping with the underlying pro-style and integrational direction of much of the work in JAM; that style is something which comes from inside, that it is about the way you are and the way you express it - indeed, live it - that matters. Individuality and confidence in being yourself is the key in work by style heretics, photographer David Sims and fashion designer Alexander McQueen, and in the real life subjects of photographers Rankin, Phil Knott and Donald Milne. Leading multimedia artists Anti-Rom and the graphic design and communications outfit Fuel address this same issue with a rare humour and intelligence. Art directors Blue Source have made empowerment and integration the underpinning of all that they do.

Photographers, musicians and designers are collectively sticking two fingers up at the received wisdom from above. And yet, subversion sells and the subversives of today are almost immediately assimilated by corporate giants like Nike, Diesel, Condé Nast, Calvin Klein, et al, with their insatiable appetite for using cutting-edge talent to good marketing effect. On the music front, jungle, which was once considered to be the ugly side of the rave scene, now has its own slot on Radio One. Not that commercialism or popular appeal is in itself a bad thing, but the challenge for producers is to retain their integrity, the capacity to touch base and a willingness to take risks, or else they could be speedily replaced by the next up-and-coming young talent who has nothing to loose.

jane alison

9

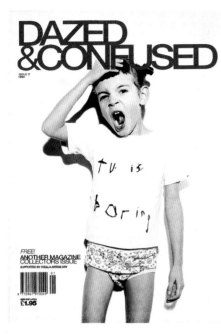

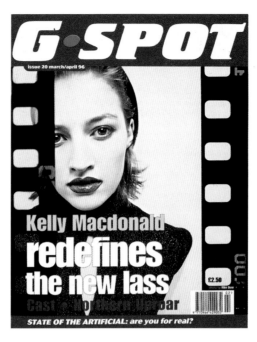

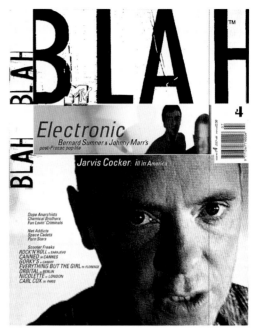

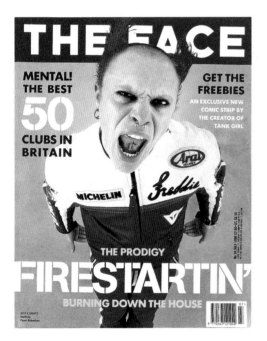

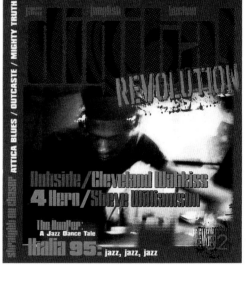

title:dazed & confused
editor:jefferson hack
design direction:ian c taylor
photograph:rankin

title:the face
editor:richard benson
art direction:lee swillingham
design:craig tilford
photograph:peter robathan
styling:jason kelvin

title:g-spot
editor:joe gatt
design:taren mccallan
photograph:mike diver
styling:yolande mcc

title:a be sea
publisher and editor:sebastian boyle
art direction:david james
design:gareth hague
+malcolm webb at david james associates

title:blah, blah, blah
publisher and editor:marvin scott jarrett
art direction:substance
photograph:peter anderson

title:straight no chaser
editors:paul bradshaw+
kathryn willgress
art direction:ian swift
photograph:pav modelski

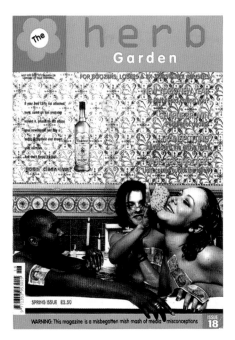

DEAD.
Fuel

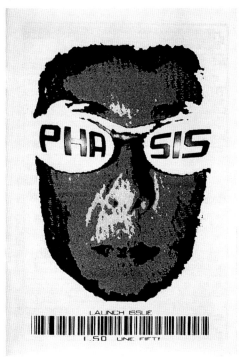

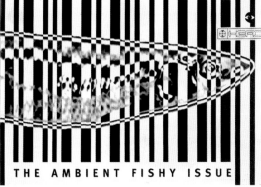

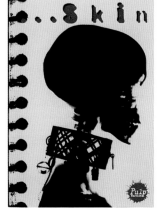

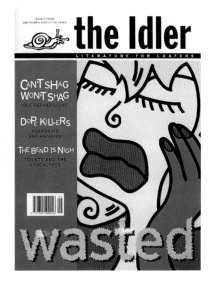

title:**herb garden**
editor:**david gill**
design:**martin appleson**
photograph:**steve hall**

title:**dead fuel**
producers:**fuel**

title:**phasis**
producers:**justin hammond+
martin lesanto-smith**

title:**head**
producers:**mobile d unit+
the faceless networker**

series publisher:**pulp faction**
editor:**elaine palmer**
skin:art direction:**bettina walter+
fabian monheim**

title:**experiment**
publisher and editor:**stephanie tironelle**
design:**mike lawrence**

title:**the Idler**
editor:**tom hodgkinson**
art direction:**gavin pretor-pinney**
design:**mark leeds**
illustration:**celipé garcia**

what's occurring?

What's occurring? Interactivity is the order of the day, and I don't just mean the variety you enjoy in shoot 'em up arcade games. A new generation of doers are trampling over the barriers between the cultural and artistic ghettos, and where once we clung to our specialities, now we strive to be polymaths. Image making is integral to the creative process, and is easily re-cycled. A painting becomes a t-shirt, becomes a poster, becomes decor in a club, becomes an invite, becomes a short-run publication, becomes a record cover. It mutates and evolves...

One obvious reason why...the computer is the facilitator. But beyond the simple mechanics of scanning, manipulating, posting and pasting, which puts every image up for grabs and makes a mockery of copyright laws and the concept of cultural property, technology allows for new working practices, and has assumed the role of a metaphor. Systems and networks exist digitally, but they also exist in the imagination, in the flesh, and in the arteries and nodes of the city. And London is the city. Thanks to the fact that

we speak English, aren't yet a US colony, and are happy to trade in quirks and celebrate eccentricity, the UK enjoys a peculiarly privileged position in the imagination of the world's visual, musical and stylistic obsessives.

The actual production of some of the most innovative media on this planet takes place within a few unassuming square miles - stretching from Shoreditch in the east to Kensal Green in the west, north and south from Camden to Brixton, and centring on Soho - away from the tourist trails, but not hidden.

The thing about all the media celebrated here is that at some point in the process of creation a graphic designer gets involves. Before a "thing" - whether it's a dress or a track - is presented to a wider audience it undergoes a transformation, into an image ready for dissemination through the media. Collaboration between makers and image makers is fundamental to music and fashion, neither of which can exist in the market place without

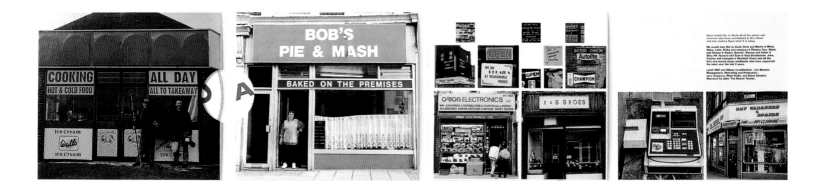

that added visual input. And that's when the network comes into play.

The graphic designer isn't simply called in the end of the creative process to package and sell. Because all the work featured here has at some point, during its production or dissemination been 'processed' by computer, these practitioners speak the same language and are to be found in the common working position - the scrum huddled before a screen. Graphic designers are also fans, and allegiances are established via personal contact and shared experiences. Connections are made on the scene, at college, or through friendly recommendations. The routes may be varied, but discernible patterns can be traced.

Graphic designers who work for the music industry often began designing flyers for their own bands or clubs, graduating to record covers via friends with jobs in A&R who turn into clients. From staging slide shows and painting backdrops for one-nighters, to directing promo videos and television ads,

it's a similar leap. The route into fashion could come through a student placement on a cult-status magazine, forging allegiances with fashion designers and stylists who are mates from college, or championing young photographers who wander in to show off their work.

The point is that the mainstream is hungry for all this underground activity. And these connections, based on favours, working for nothing, and getting things done beneath the shadow of the '80s boom and early '90s bust, have come to fruition. When you're struggling through a recession you need as much help, inspiration and solidarity as you can get. Now we're seeing those small beginnings made good, and those loose, nurturing structures growing into a branch of the media industry which is rooted first and foremost in cooperation and having fun.

liz farrelly

title:**open - an open minded collection 13**
label:**ministry of sound (open records)**
design and art direction:**scott parker**
photographs:**ben jennings 1996**

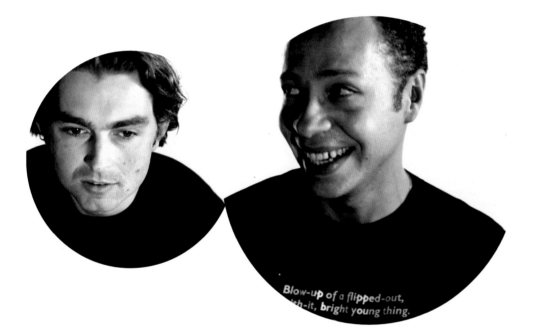

Blow-up of a flipped-out, ith-it, bright young thing.

Q:how would you describe your work

A:michael and james:blow is an antidote to all other fashion magazines. it can save you from overdosing on fashion and we still can't believe we're the only magazine in the world taking the piss in the way we do.

just connect

When I first moved to London, it took me about three years to realise that Highbury and Archway were in fact next to each other and that the Holloway Road connected them. It took me considerably longer to realise that all the 'style' industries - fashion, music, clubbing, advertising, etc...were linked in just the same ways, and their Holloway Roads were the people who straddled the different disciplines.

That they do crossover is testament to the fact that youth culture in this country is one of the few places where Major's sound bite about the 'classless society' actually means something. Forget clubs you need to wait years to become a member of, the only clubs that count here are the sort with low

lights, loud music and dodgy toilets. It is in the dodgy toilets that the people shouting into each other's ears are more likely to be sorting out their next job than their next fix.

That the job, at this level, is almost certainly based on favours and not money illustrates another powerful aid to this culture in this country - the Welfare State. Many of those lambasted by the gutter press as spongers and wasters are simply people pursuing their desires and using their talents to create something instead of wasting it behind Tescos' checkout, asking customers if they'd like bonus points with their weekly shop.

By the time these people have begun to rise in the

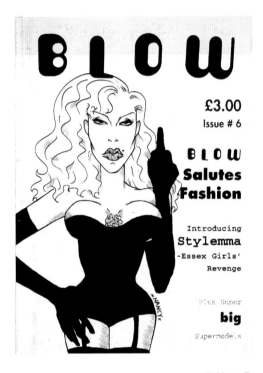

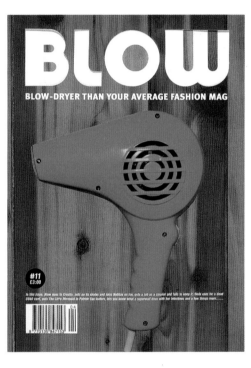

title:**blow#5**
editors:**james pretlove+michael oliveira-salac**
creative direction:**lola**

title:**blow#6**
creative direction:**lola**

title:**blow#11**
art direction:**10x5**

hierarchy, that poverty under which they lived for so long has combined with what is after all a very small scene to necessitate the forging of those connections which JAM is all about. Journalists work with fashion designers and film-makers with ad agencies. The pinnacle of this culture is the brit pack who work abroad - Galliano for Givenchy or Tilberis for Harpers Bazaar.

But best of all is that urban youth can quite happily steep themselves in this culture without ever having known who, for instance, Buggy G Riphead is. For them, he might just as well be a character from Viz as a computer artist/graphic designer. Left unexplained, urban youth absorb the culture by osmosis

The trainers they saw last weekend will be the ones they buy next weekend; the track they heard at a club last night will be the one they hum as they buy it at Tower Records tomorrow.

The young don't need to know the connections any more than I needed to know that Highbury and Archway were connected; however, once you know Holloway Road is there, you begin to feel as if you're part of something wonderful. And that is what JAM is here to do.

james pretlove

Q:how would you describe your work

A:true magazine is a cutting-edge urban magazine that aims to push hip hop and
street style to the forefront of urban culture. my job is to make sure this happens.

inner city life

With the majority of Britain's Afro-Caribbean community concentrated in the London metropolitan area, it is no wonder that the Notting Hill Carnival is seen as a culmination of the Afro-Caribbean year. When inner-city pressure turns into street-level celebration of both tradition and modernity, London's many communities come alive through music and dance. Gradually, the reggae sound systems have muted their slow cadence and mutated into the polyrythmic language of multi-cultural London.

The new, daring boom boxes which appeared in recent years - and blasted loudest at Carnival - are driven by London youth in their fascination with the next big bang. Charting the evolution of Carnival music you find that those young Londoners who recognise themselves in the ragga, jungle and hip hop subcultures are the very ones who will break with tradition, and break new ground, by fusing borrowed beats with manipulated vocals to create whole new genres.

This is the London I discovered in the late '80s and fell in love with. I'd come from Paris for a weekend and decided to stay on. Now, having chosen to chronicle the lives and times of young Londoners through True magazine, I find that any exploration or explanation must start with music. As the concept of 'street style' is being twisted so that the musical connection is obscured and made to appear less evident, I've come to the realisation that London will always be at the cutting edge of music - and therefore style - because it is very densely populated by young artists who know that experimentation is the only way forward. As a music journalist I find that I am rarely detached enough from the scene to notice the subtle societal shifts created by musical mutations. Recently, though, I attended a Fugees' concert in London and witnessed certain changes in attitude and behaviour that made me realise how quickly the urban landscape has altered since I first moved here.

At first glance I thought that the crowd was mostly composed of twenty-something hip hop heads who'd come to watch the band of the moment, but upon closer inspection I was struck by

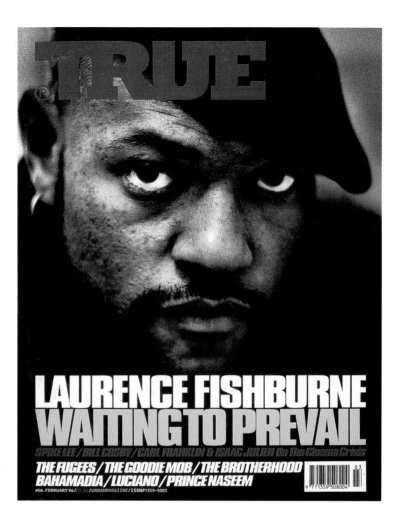

TRUE

LAURENCE FISHBURNE
WAITING TO PREVAIL

SPIKE LEE / BILL COSBY / CARL FRANKLIN & ISAAC JULIEN On The Cinema Crisis

**THE FUGEES / THE GOODIE MOB / THE BROTHERHOOD
BAHAMADIA / LUCIANO / PRINCE NASEEM**

#06 . FEBRUARY 96 / £2.50 / URBANMAGAZINE / ISSN#1359–5083

the ecleticism of the Fugees' London following.

If you weren't too busy staring from afar at Sade over at the bar you could have watched the tail end of a conversation between a clued-up ragga girl and a laid-back soul boy. Though their styles of dress differed sharply, the very fact that they were enjoying each other's company, and grooving to the music that wouldn't normally fall within the delineations of their preferred genres, confirmed the general feeling that mid-'90s Londoners are about to overtake their European competitors and restore the city to Swinging Sixties-era glory.

At the heart of this regeneration is jungle music which, I feel, is the single most important new contribution London has made to the world. Having moved beyond the basic programming of the drum and bass, the jungle vanguard is re-inventing urban music for a new generation of street-wise, fired-up city kids. The new establishment members are producers such as LTJ Bukem and Goldie, DJs Grooverider and Rap, MCs 51ve O and Det. Together, they are leading the way to what I suspect will be a golden age for creativity, achievement and all round enjoyment. The future has never looked brighter and I couldn't imagine experiencing the countdown to the millennium anywhere else.

claude grunitzky

title:**true 17**
publisher and editor:**claude grunitzky**
art direction:**matt roach**
photograph:**nicolas hidiroglou**

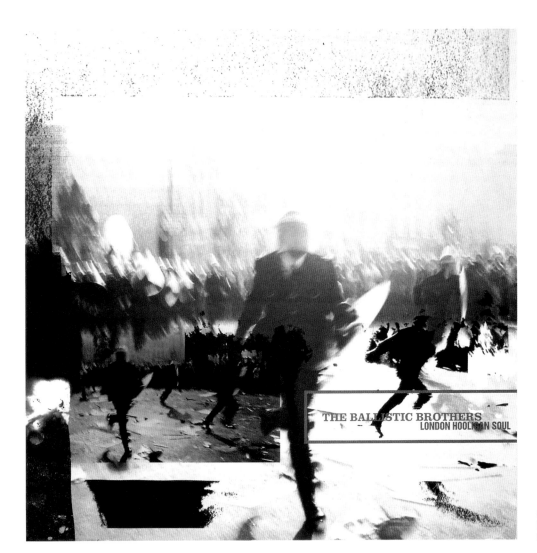

artist:**the ballistic brothers** title:**london hooligan soul**
label:**junior boys own** photograph:**dave hill**
design:**simon earith+jonathon cooke** 1995

Our attitude...

'If you're gonna live/Then live it up/And if you're gonna walk the earth/Then walk it proud/And if you're gonna say the word/You got to say it loud.

If you're gonna step/Step on it/If you're gonna finish/You got to begin/If you're gonna help/Reach out your hand/If you're getting up/Then take a stand.' - Ben Harper

As a Creative Communications organisation, Blue Source contributes to the vast avalanche of images and messages which permeate our society and influence how we behave and therefore who we are. Increasingly we define ourselves by what we buy. As we learn more about the commercial mechanisms which create most of this language, we are becoming increasingly concerned about the quality of ideas which contribute to our identity.

The same technology that drives consumerism and the attendant media explosion has simultaneously empowered us with instant access to cultural reference points, limitless avenues of choice and information, on a global scale. Consequently, the opportunities to express ourselves creatively and communicate ideas effectively have never been so great.

So, if we have the courage to use our ability to seek out and define our own meaningful realities, the possibilities are in fact endless. Blue Source's collective vision aims to bring about unity and enlightenment through creativity. Our purpose is to gain fulfilment by inspiring change and improving the quality of life. We value: spirit, equality, positivism, creativity, self-expression, love, fun, professionalism, honesty, commitment, freedom and wisdom.

¹⁸ blue source

danny boyle, jonathon cooke, simon earith, leigh marling, sebastian marling, damian mckeown, mark tappin, rob wallis

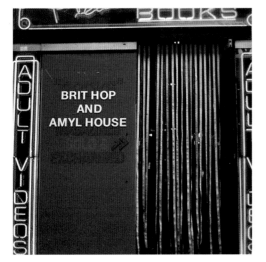

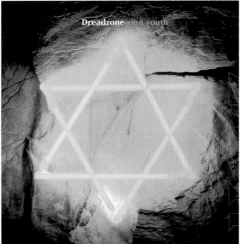

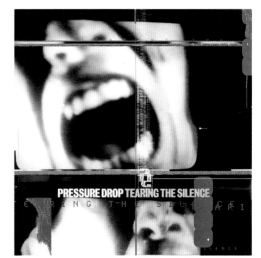

title:**brit hop and amyl house** label:**concrete**
photograph:**amber rowlands** design:**mark tappin** 1996

artist:**dreadzone** title:**zion youth** label:**virgin**
photograph:**merton gauster** design:**jonathon cooke** 1995

artist:**pressure drop** title:**tearing the silence**
label:**hard hands** design:**jonathon cooke** 1995

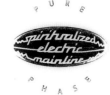

artist:**spiritualised** title:**electric mainline**
label:**dedicated** design:**jonathon cooke** 1993

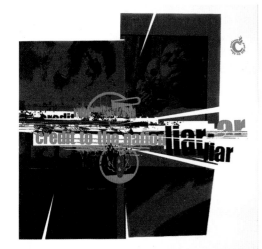

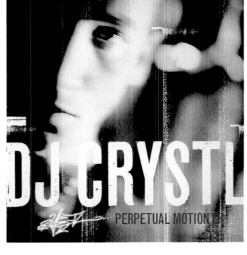

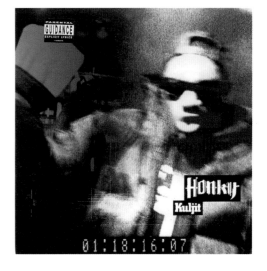

artist:**credit to the nation** title:**liar liar**
label:**one little indian** photograph:**tom sheehan**
illustration:**david o'higgins** design:**mark tappin** 1995

artist:**dj crystl** title:**perpetual motion**
label:**london records**
design:**jonathon cooke**+**simon earith** 1995

artist:**honky** title:**kuljit** label:**columbia** 19
photograph:**phil knott**
design:**jonathon cooke**+**simon earith** 1996

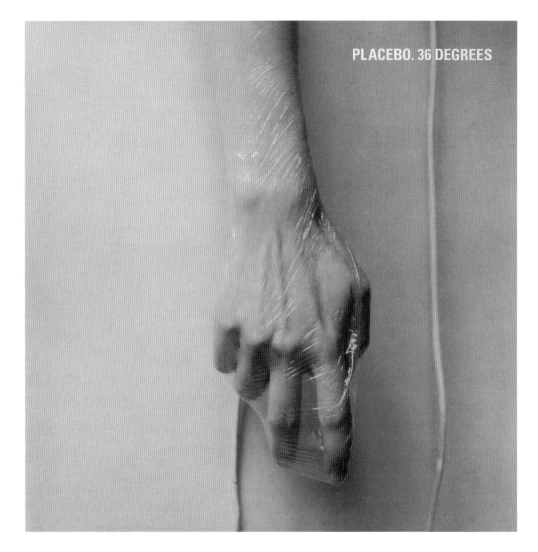

PLACEBO. 36 DEGREES

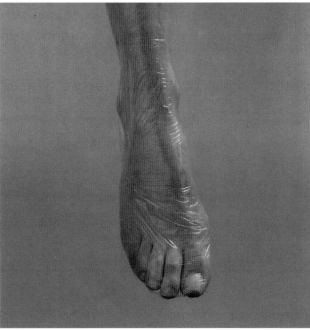

20 artist:**placebo** title:**placebo** label:**hut**
photographs:**saul fletcher**
design:**jonathon cooke+mark tappin** 1996

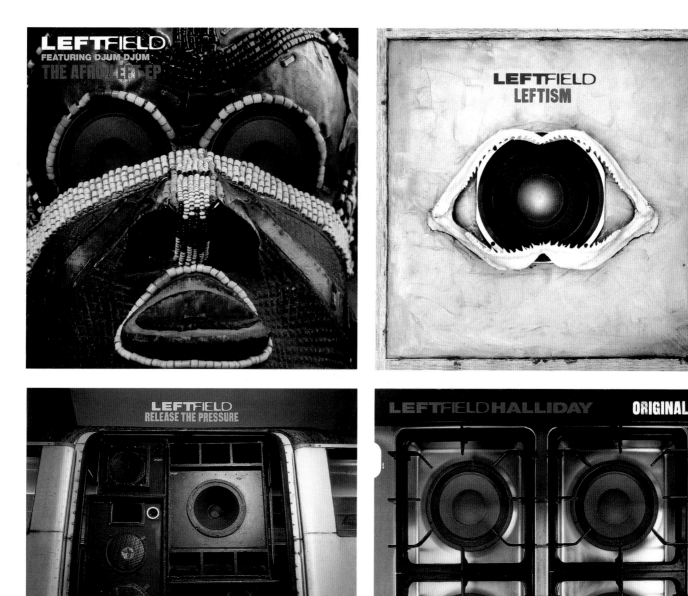

artist:**leftfield** title:**afroleft** label:**columbia**
photograph:**amber rowlands** design:**jonathon cooke** 1995

artist:**leftfield** title:**release the pressure**
client:**columbia** photograph:**derek santini**
design:**jonathon cooke** 1995

artist:**leftfield** title:**leftism**
label:**columbia+hard hands**
photographs:**merton gauster+phil knott**
design:**jonathon cooke** 1995

artist:**leftfield** title:**original** label:**columbia**
photograph:**derek santini** design:**jonathon cooke** 1995

Fuel 33 Fournier Street **Spitalfields** LONDON E1 6QE

TELEPHONE 0171 377 2697 FAX 0171 247 4697

DATE

Jam Exhibition – personal questionnaire

Q. How would you describe your work?

A. Forthright communication.

Q. In what sense do the things you believe and the things you
value inform your work?

A. Our work makes sense of the things we value.

Q. Explain why you are either pro or anti-fashion?

A. We are pro-fashion because it gives a transparent indication
of what we can expect to find inside.

PETER MILES DAMON MURRAY STEPHEN SORRELL

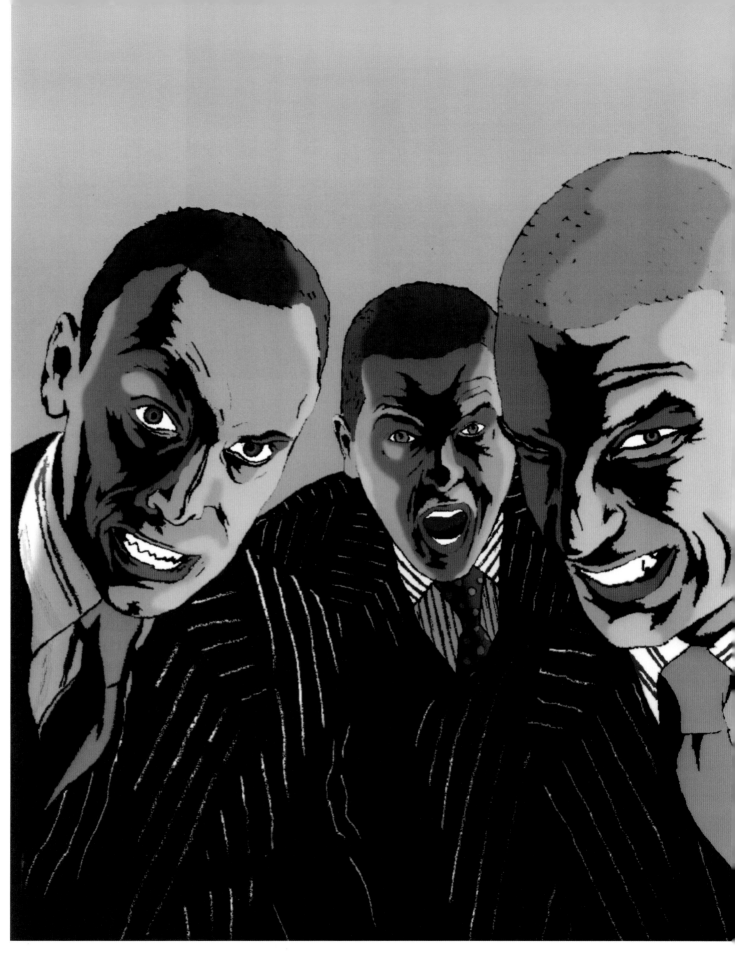

title:**fuel on fashion** medium:**video 25**
copywriting:**richard preston** 1996

STRANGELY, THE BIGGEST STARS DIE YOUNGEST.

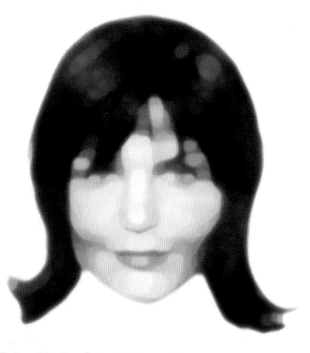

A COUPLE OF POINTS ABOUT STARS.

i'm pro-fashion when it's not up
when it is [michael oliveira-salac, b
& alison]. i am anti-fashion but pro
not anti-fashion. i'm anti-fashion s
beyond fashion [andrew cameron, a
we are all members of a super
demonstrate our feelings and emoti
fashion is a business so the quest
driver or anti-bus driver? [anet
orchestra or an exhibition of whis
others and deplore it in myself [du
[nick griffiths]. oh plllease [robert
that people can spend money to look
nothing [tomas roope, anti-rom]. i
expression, and i'm anti-fashion
in obsolescence' - what an imm

s own arse and anti-fashion
v). fashion is quite funny (antoni
yle (claude grunitzky, true). i'm
ery (james pretlove, blow). I am
i-rom). anti-fashion is a fashion.
ribe and fashion allows us to
s beyond words (brian of britain)
n doesn't apply. are you pro-bus
aurel). yes or no? mint nylon
ig? (tomato). i love fashion in
ell bishop). i am pro-creative
quesne, anti-rom). it amuses me
silly as someone who has spent
pro-fashion when it's about self
hen it's an excuse for 'built
se waste of effort and resources
(liz
farrelly).

normally i've got a mohican

Q:explain why you are either pro or anti-fashion

A.

Q:how would you describe your work
A:that's a very difficult question - I don't feel I can describe my work.
but, I'd like to think it was unpretentious, that it has a sense of humour
and that I can effect some progress or encourage a change in attitude.

³⁰ **david sims**
styling:anna cockburn

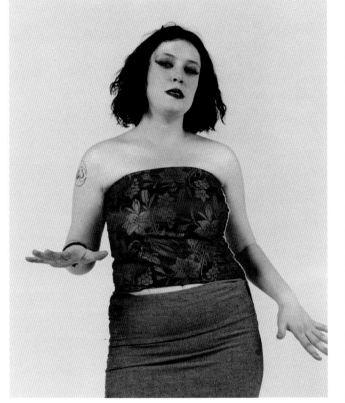

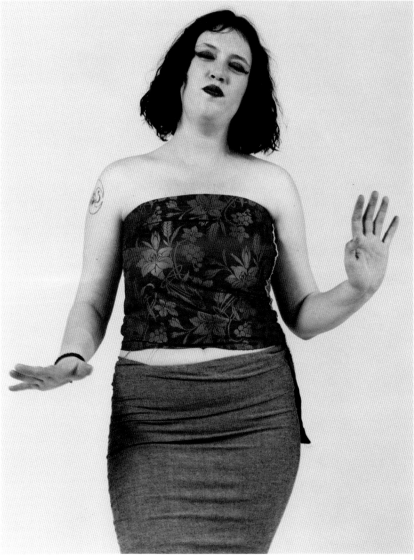

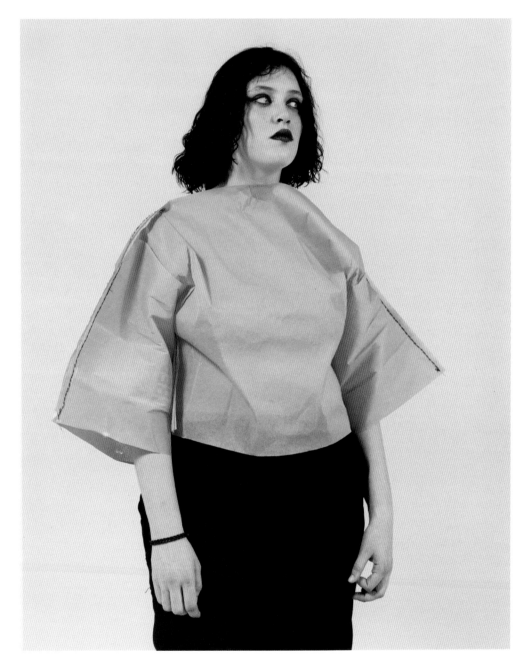

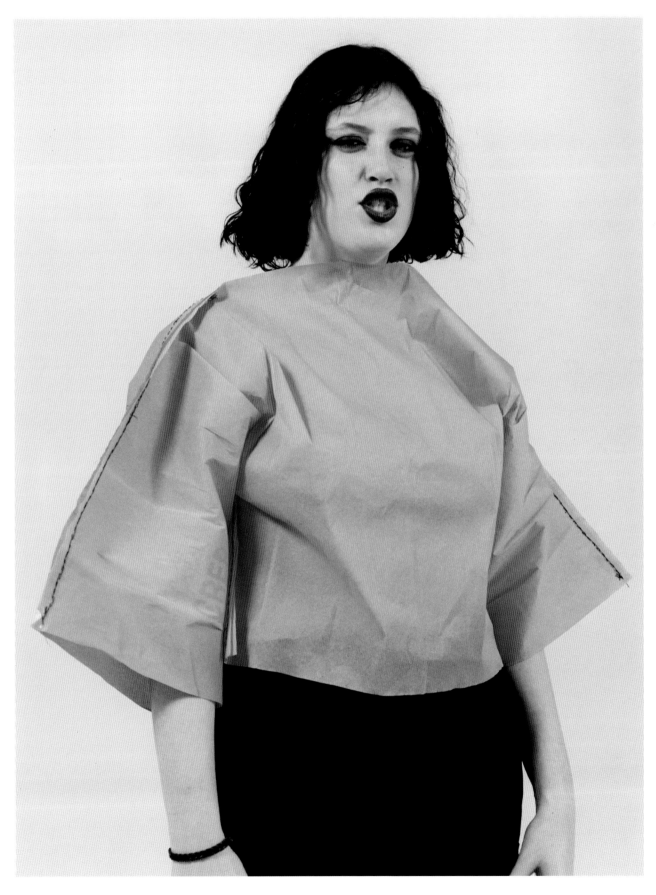

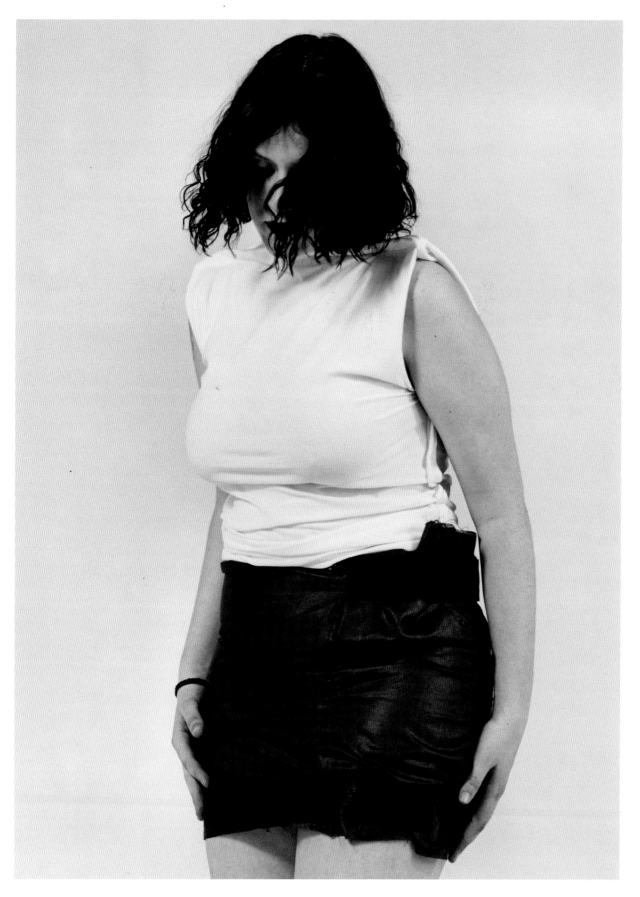

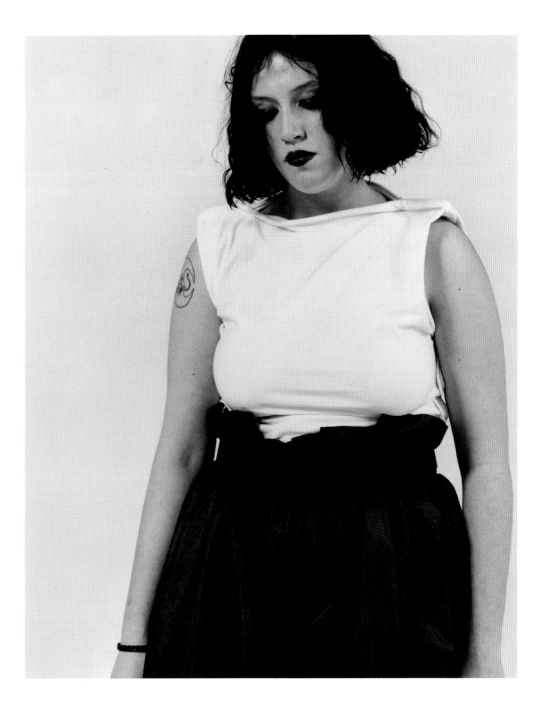

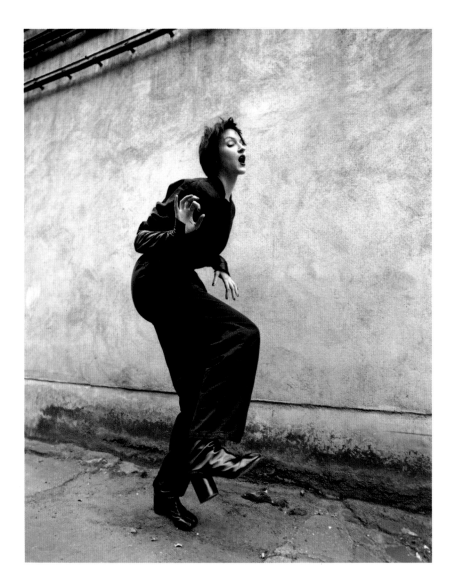

anette aurell
Q:how would you describe your work
A:I always try to be sincere in my own way -
some people tend to over-analyse....

annett monheim
Q:how would you describe your work
A:personal. quirky. not based on fashion-as-beauty-trend but on my own phantasies and
creatures in my head. I try to understand the person I am dressing and translate this into
clothes. for editorial work I try to develop a story-line more than a clothes-line

³⁶anette aurell
styling:annett monheim

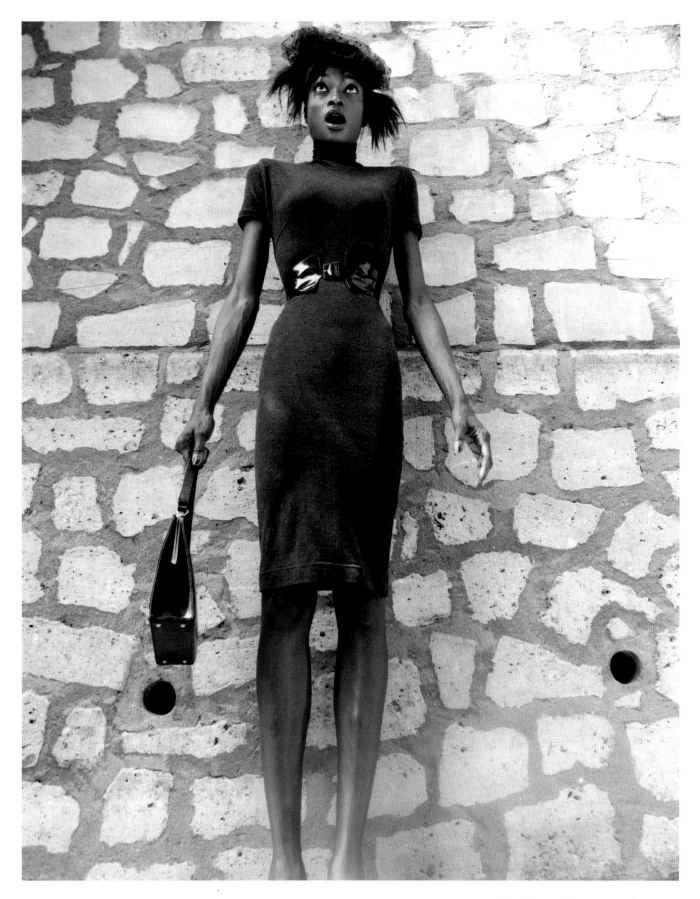

hair and make-up:mark carrasquillo at camilla arthur 37
model (opposite):teresa stewart clothes:martin margiela
model (above):debra shaw clothes:rifat ozbek

Q:simon, how would you describe your work. A:british. humorous. sexy.

Q:nick, how would you describe your work. A:like a pendulum.

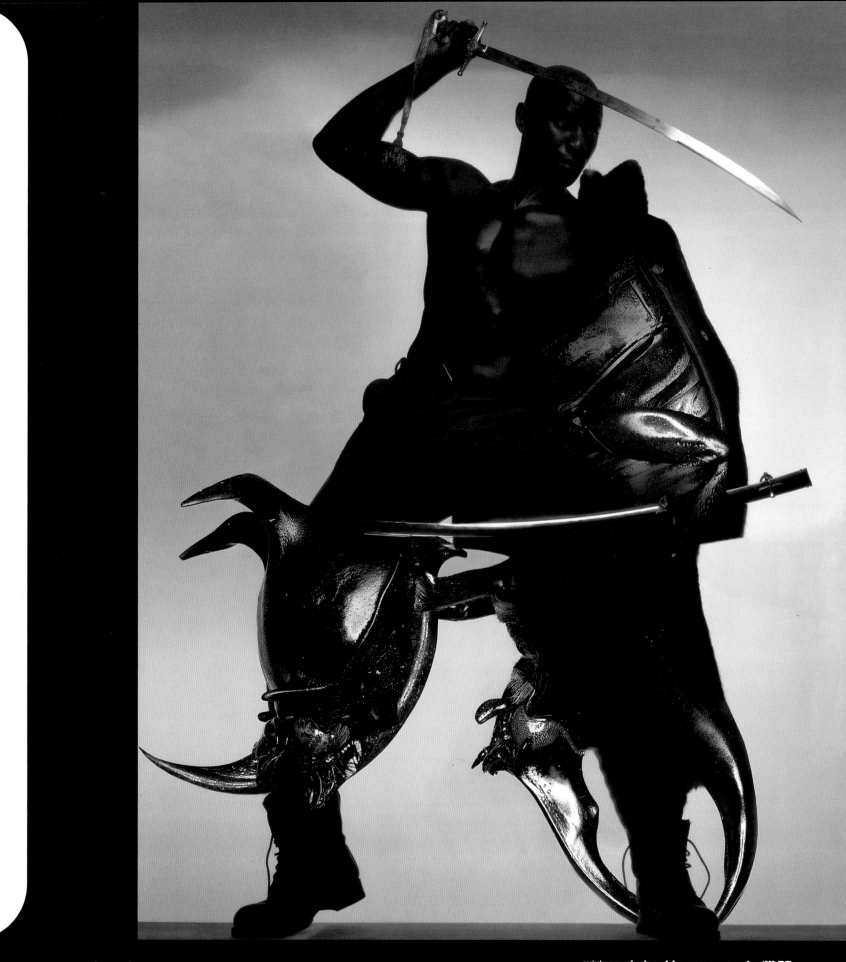

project:**commissioned by arena magazine** 1996 **39**
hair and make-up:**j sapong**
models:**roger, lawrence+david epstein**

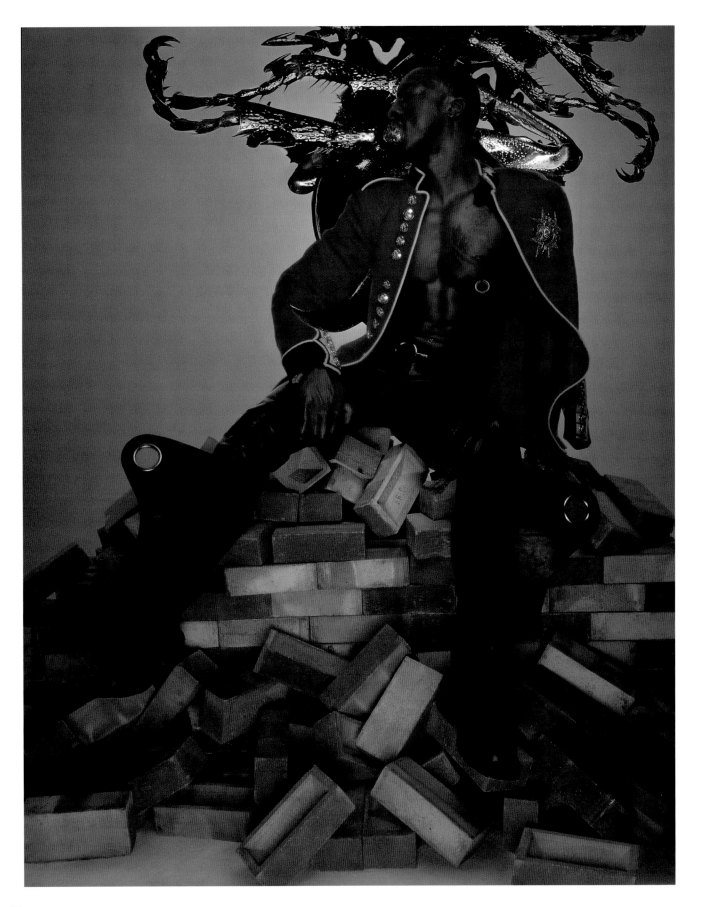

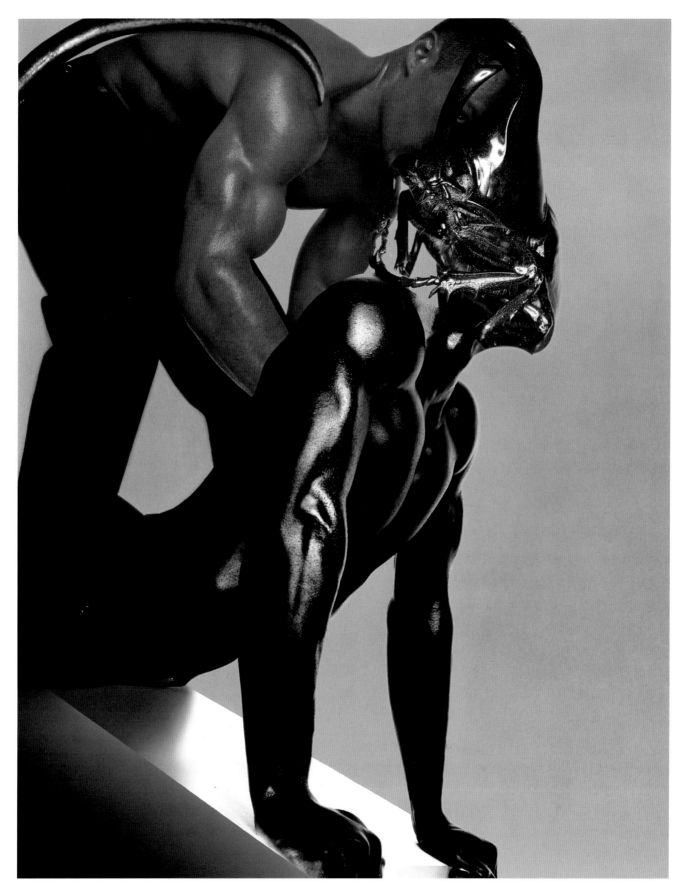

everybody has
and clothes giv
- you can be
you want to be
mcqueen)

Q:explain why you are either pro or anti-fashion

A:

a fantasy
e you that
nybody
[alexander

it really
works
for us

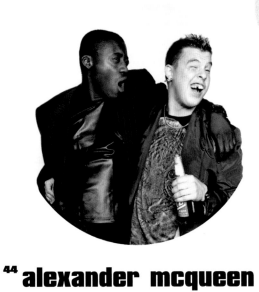

Q:how would you describe your work. A:eclectic verging on the criminal.
Q:and your attitude to life. A:criminal verging on the eclectic.

[44] alexander mcqueen

portrait with edward enninful:**kent baker** courtesy:i-d

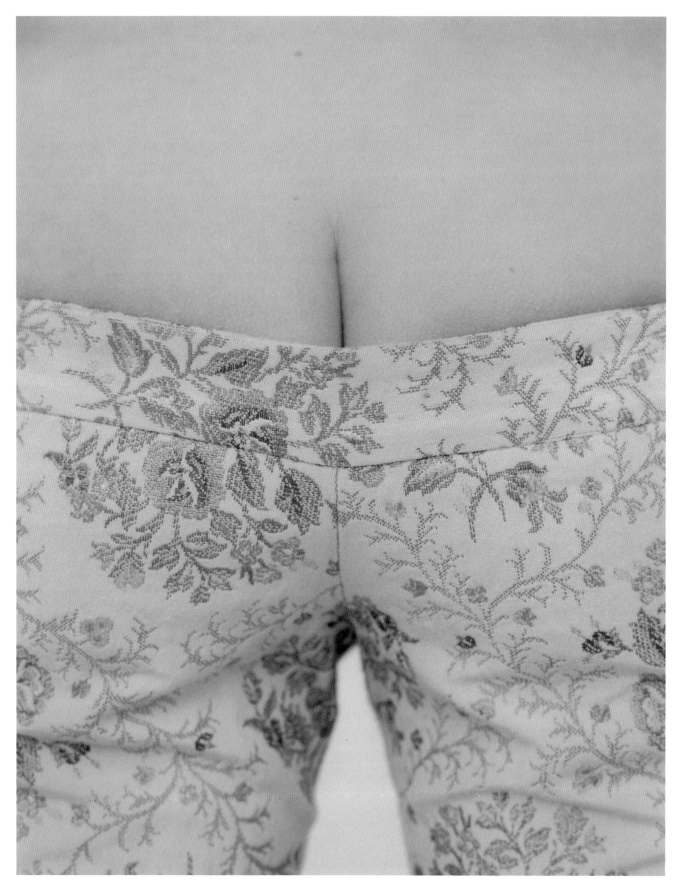

project:**commissioned by romaine lilley 45**
at guardian newspapers 1996
clothes and styling:**alexander mcqueen**
hair and make-up:**mira hyde** model:**lana**

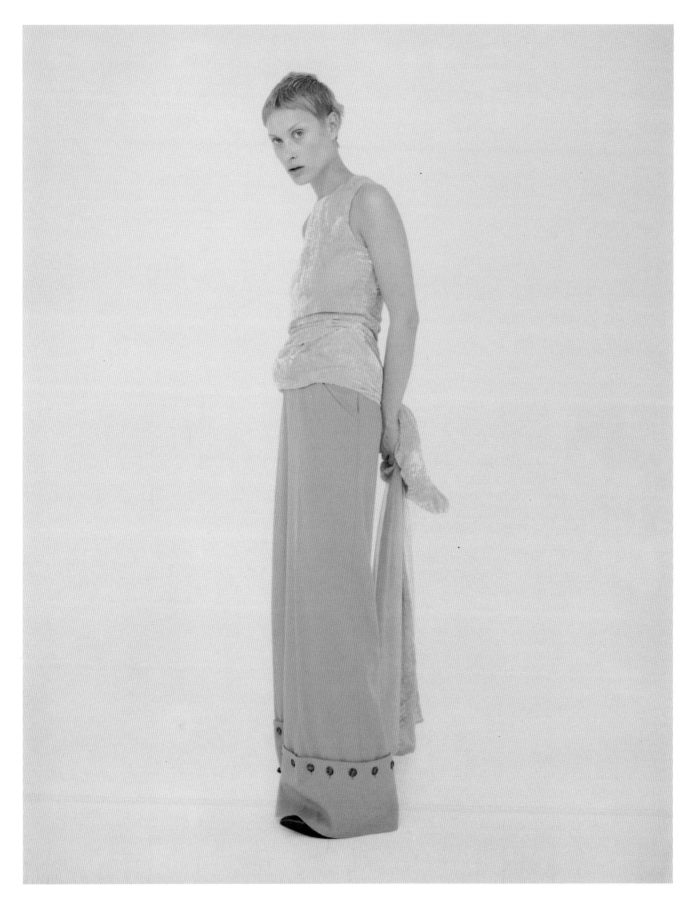

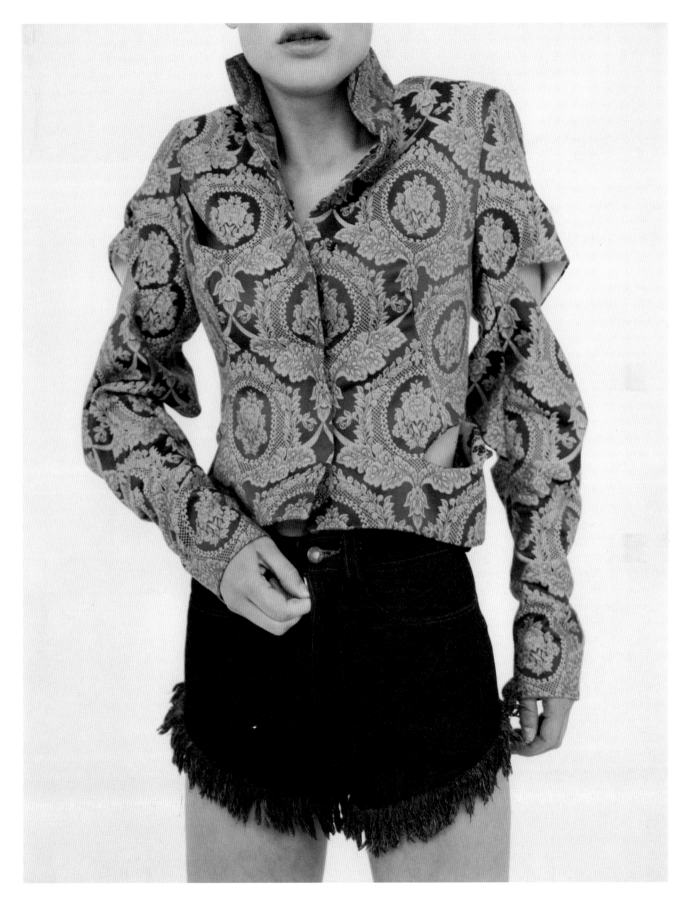

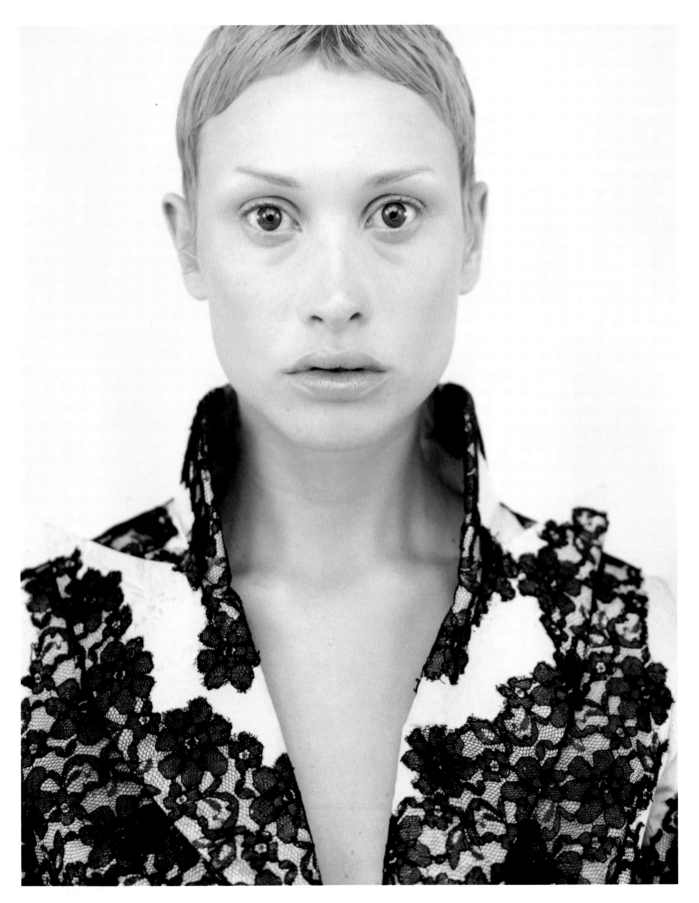

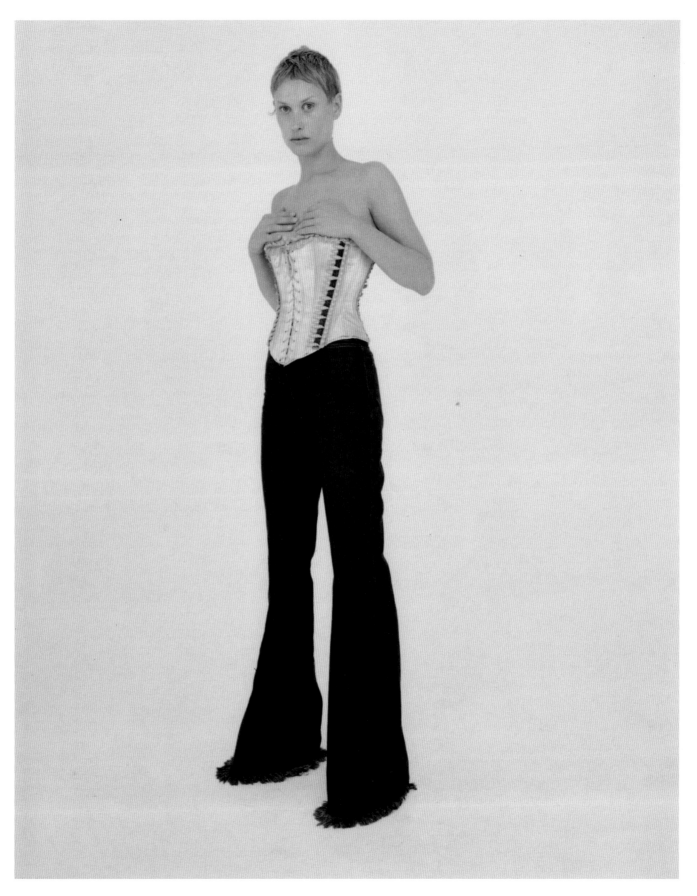

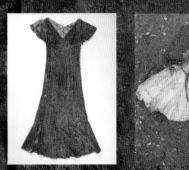

Q:how would you describe your work

A:context oriented, conveying personal theories within the realms of performance.

⁵⁰ hussein chalayan

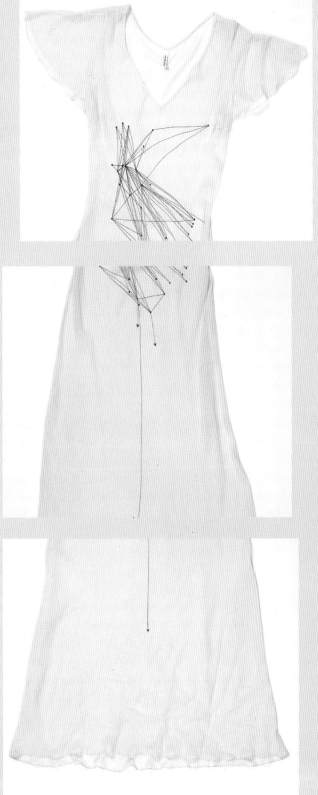

clothes[opposite and detail]:**dress and waistcoat 51**
project:**temporary interference** spring/summer 1995
clothes:**dress**
project:**long false equator** autumn/winter 1995

IT DOESN'T MATTER IF YOU LOVE ME OR NOT... I'LL BE ALWAYS THERE FOR YOU...

Q:how would you describe your work. A:freedom and movement.
Q:describe your approach to this project. A:a usual day in my life.
Q:describe the results. A:the banana still hangs in a room at the
gramacy park hotel in new york city.

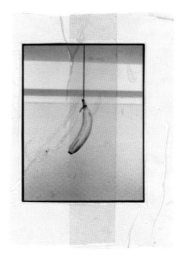

SHE HAD Reasons to Believe the
PURPOSE WAS ONly to BE a Success What Represented
TIME and WHO OR WHatevers LI f E on
the eno of a String Juxtaposed By the
VI BRANt meaning and pleasure WAS
left in tHE PAlM OF YOUR

han D and gently tHROugH
Repetitive Movements tHE

POWer was All YOURS and
One Allways knew tHE tastE
WAS Better in SIDE
OU t

MB

title:this is not a performance just real life summer 1996 53
clothes:hussein chalayan styling:jane howe
hair:sebastian richard make-up:kenny cambell
model:kirsten owen photographer's assistant:alexx

SHE WAS
SHE WAS
is

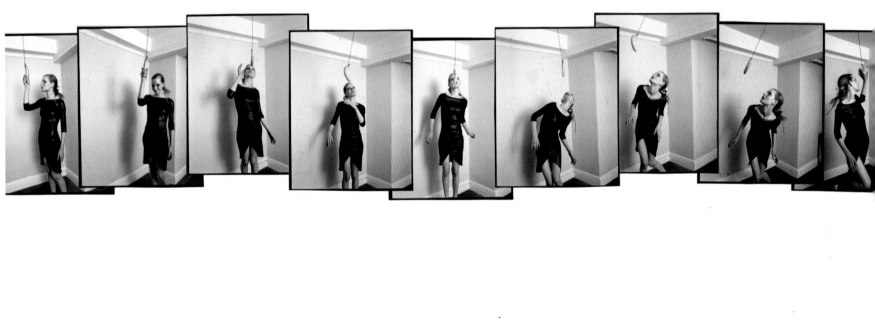

SHE WAS USED TO FOLLOWING INSTRUCTIONS RELIDING ON OTHERS
to make descions avestions Allways MADE her feel insecure SHE CLICKE
HER FINGERS AND PLAYED ON HER NERVOUS thoughts MOST
People UNDERSTOOD HER APPART FROM herSelf M

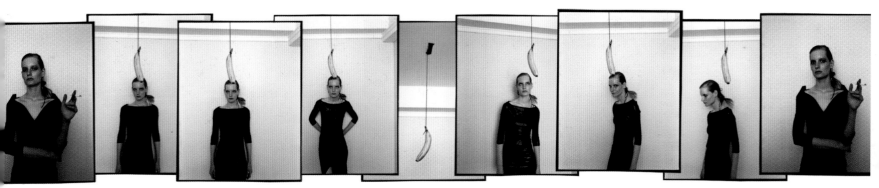

theres a strange air of
peacefullness that surrounds
her as if nobody comes
close with a giggle that
makes you wanna hold her
tight in pain m

Q:how would you describe your work A:process of instinct.

jessica ogden

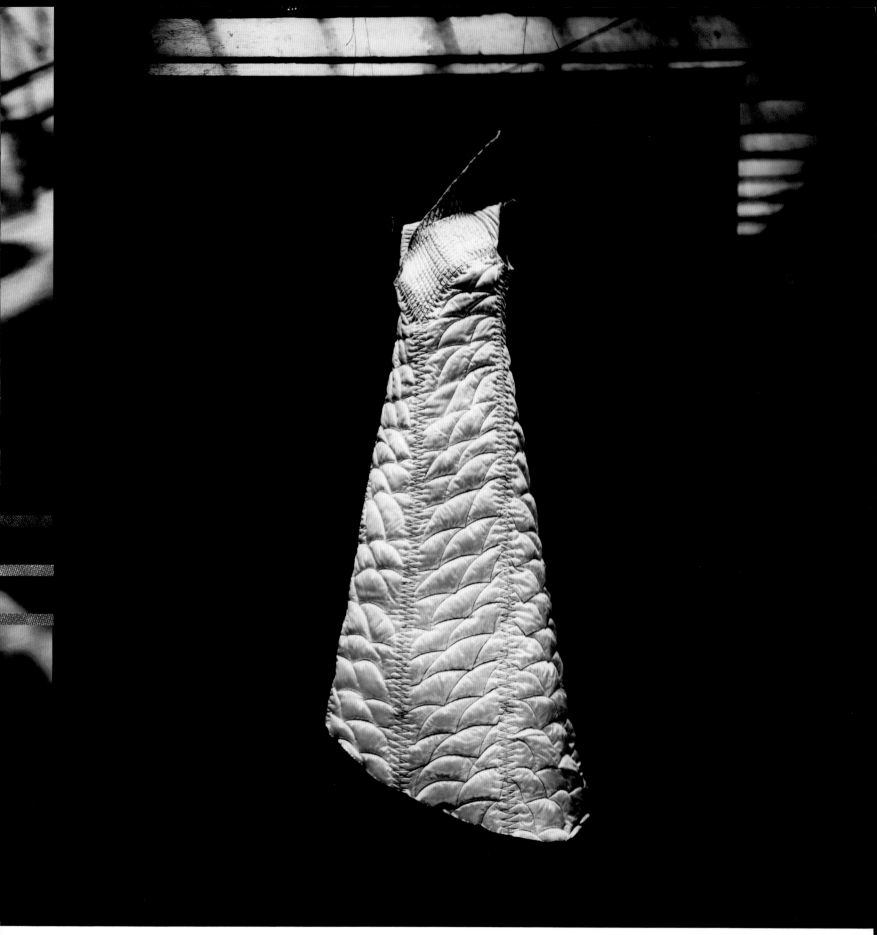

project:**dress toile** 1996 photograph:**mark lebon 57**
sponsors:**the cloth house+kliens**

Q:how would you describe your work. A:"modern couture".

brian of britain

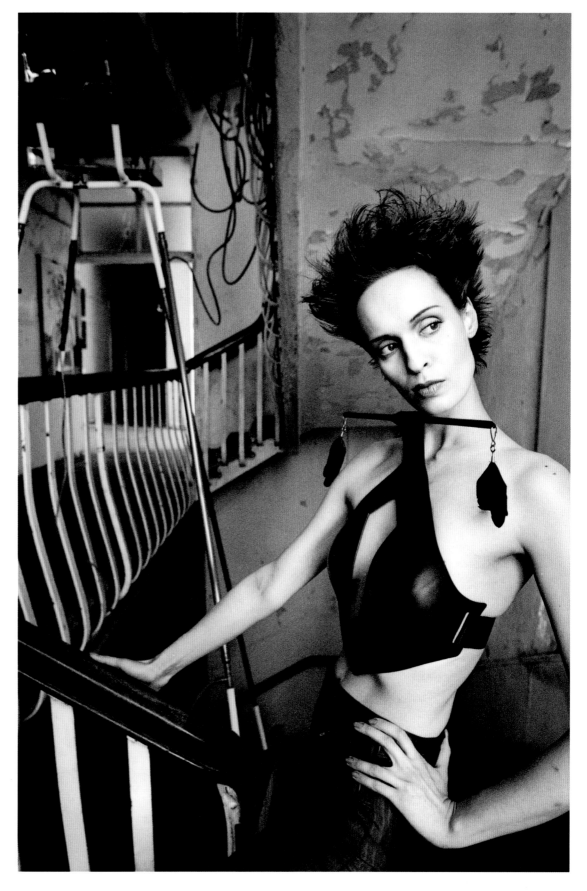

clothes:**zowie broach+brian kirkby 59**
label:**brian of britain** 1996 photograph:**vincent lefèvre**
hair:**guiseppe criscuolos** make-up:**christine mann**
model:**jackie schulz** at wild

steph
en
fuller

london

Q:how would you describe your work
A:experimentation with fabric,
technology and tailoring to create
contemporary clothing.

clothes:**coat** [detail] **and top** spring/summer 1996 **61**
dress spring/summer 1997 **suit** autumn/winter 1996
photographs:**mark mattock** model:**alek**
clothes and styling:**stephen fuller**
hair:**mandy lyons** at debbie walters
make-up:**wendy rowe** at debbie walters
sponsor:**big sky studios**

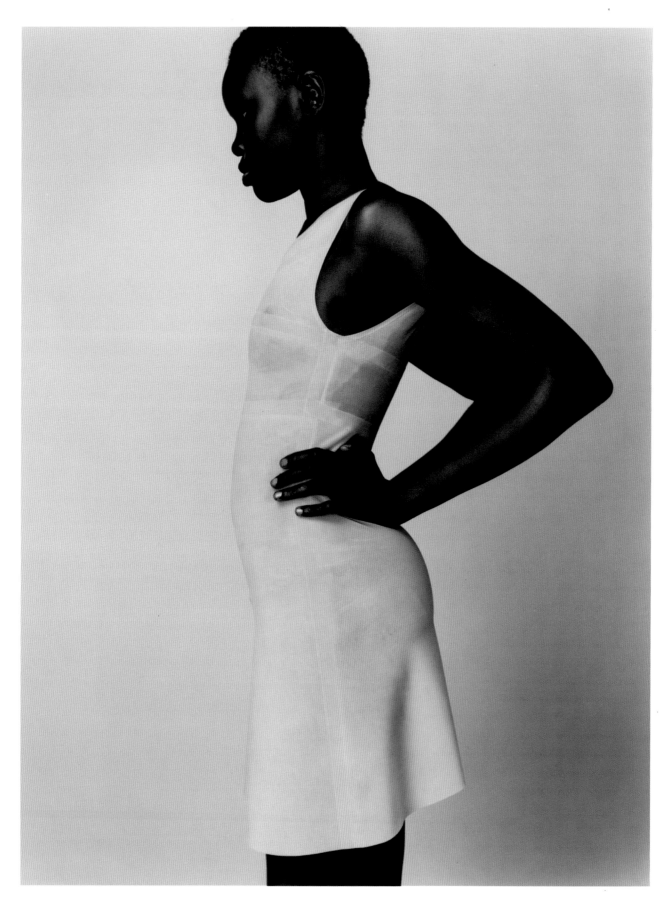

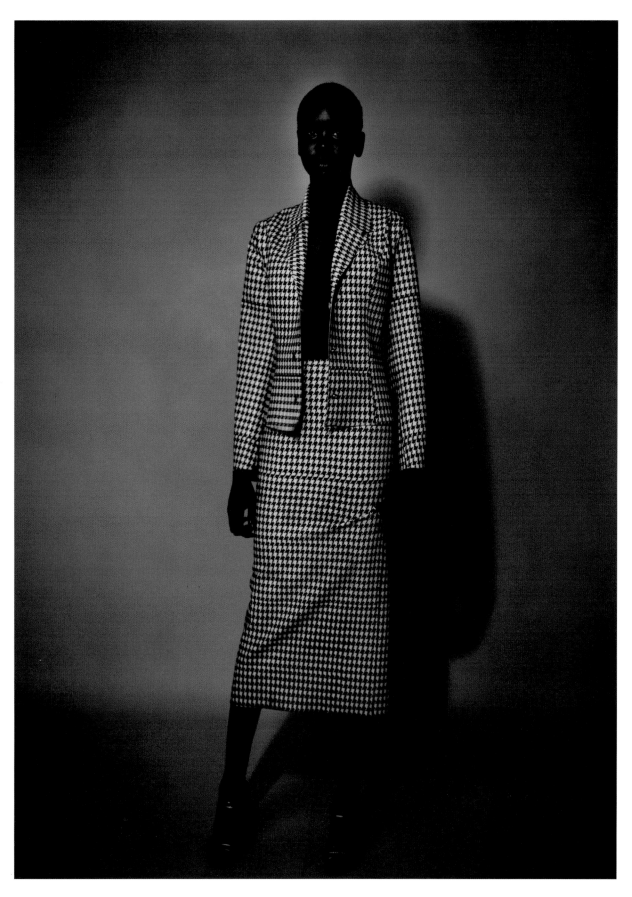

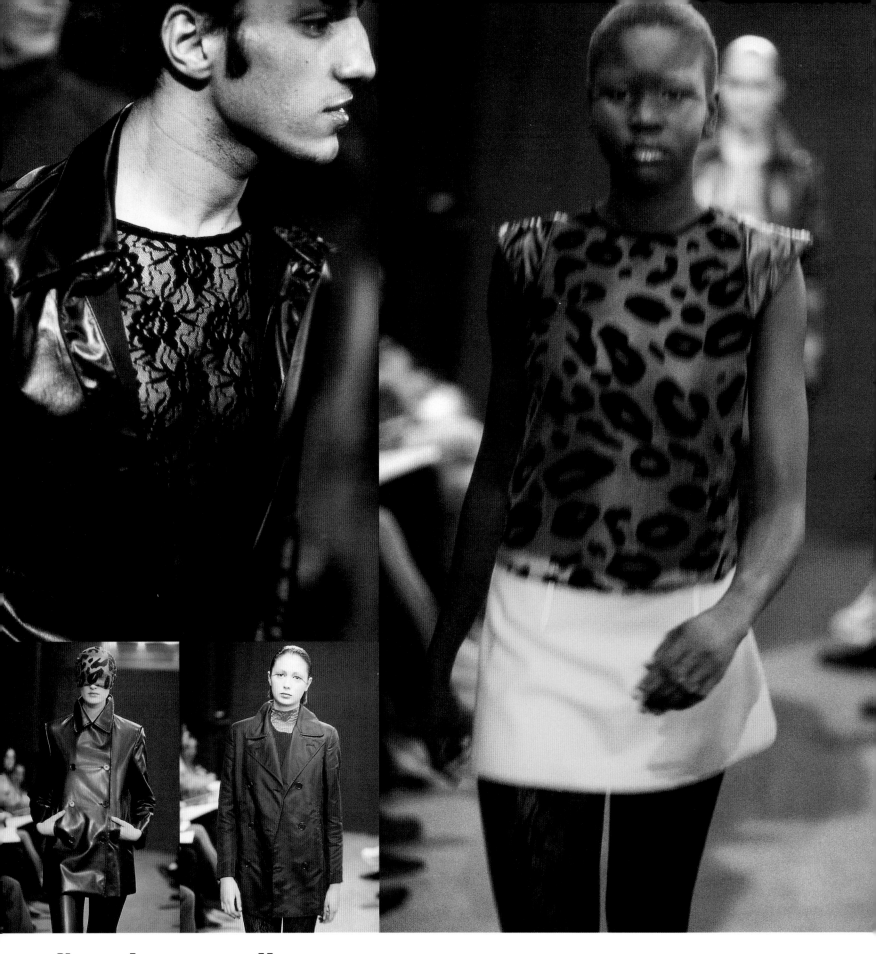

collection:**autumn/winter 1996**

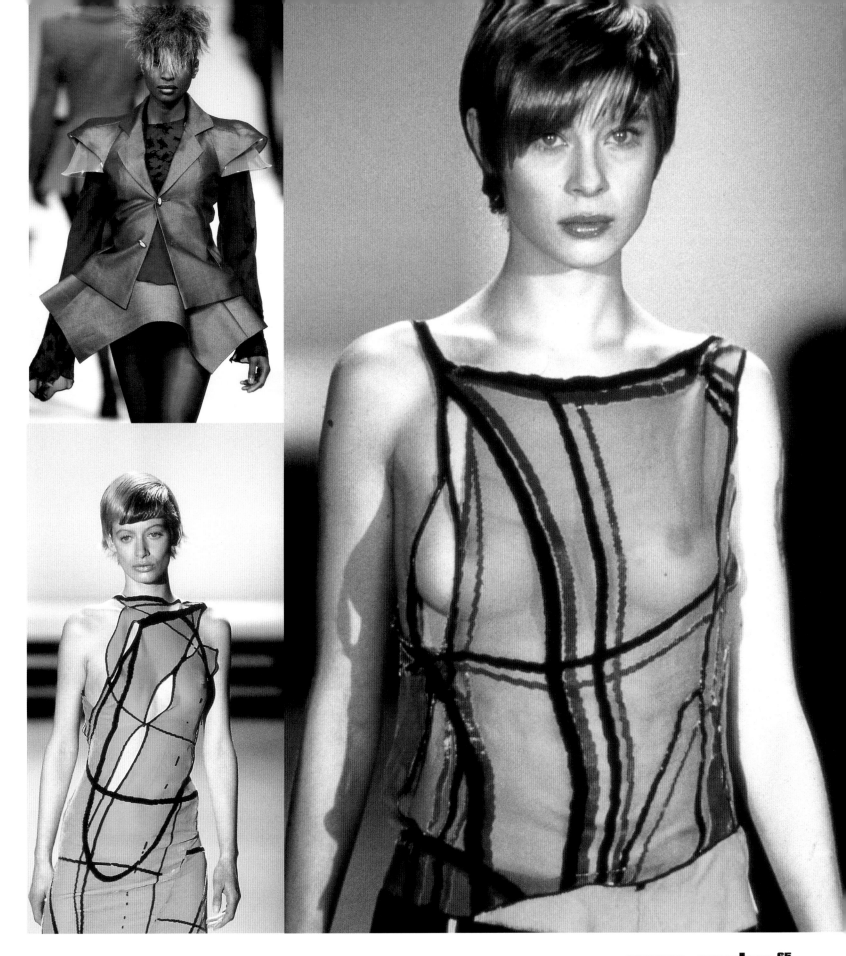

owen gaster [65]

collection:spring/summer+autumn/winter 1996

1.face

2.body

3.style

4.fabric

5.street

Q:how would you describe your work
A:always playing with the boundary between
entertainment and tools.

durrell bishop

project:interactive self-styling installation 1996

imagination and the
thoughts and feelings into real
if we read, watch, talk and listen c
of britain). friends, and the closer t
morning (antoni & alison). my childre
freedom, relatively (buggy g riphead).
and passion (alexander mcqueen).
everything (nicolas roope, anti-r
(phil knott). those here a

a pleasant chit chat
with my friends over a decent cup
of orange pekoe

bility to transform our
y. knowledge; it never ends even
stantly 4 the rest of our lives (brian
 better (liz farrelly). getting up in the
 my wife and my work (nick knight).
 eople (hussein chalayan). friends, love
 e times when nothing seems to mean
). ideas (durrell bishop). being alive
 gone, memories and dreaming
 (jessica
 ogden).

Q:what do you value most in life

A:

⁷⁰ donald milne

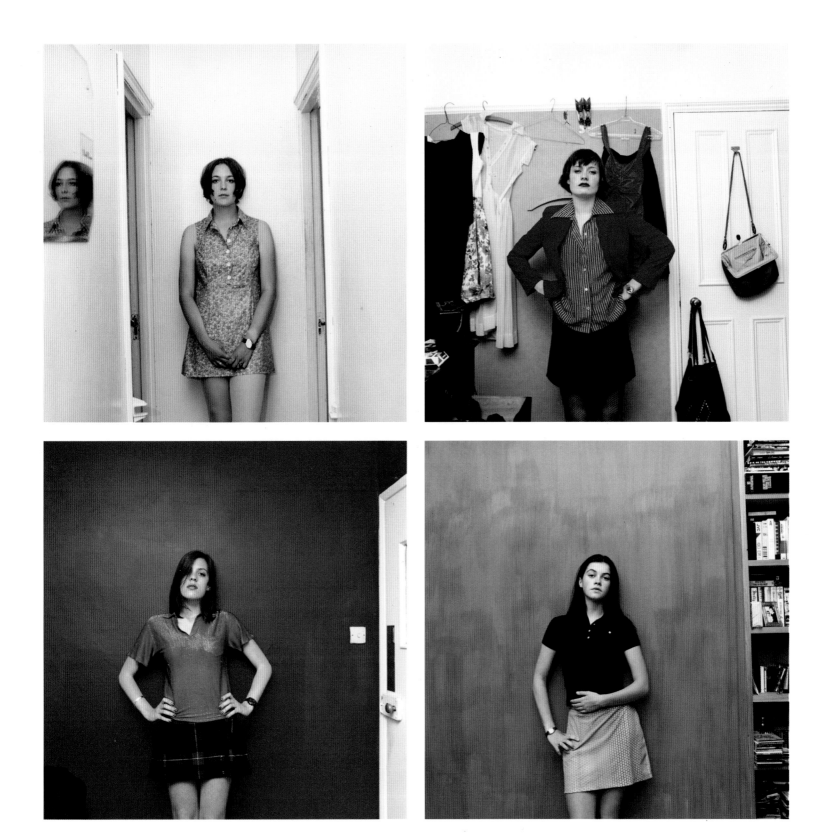

project:**girls going out 71**
photographed in their houses and flats summer 1996
clockwise from top left
titles:**dawn iris holly grace**

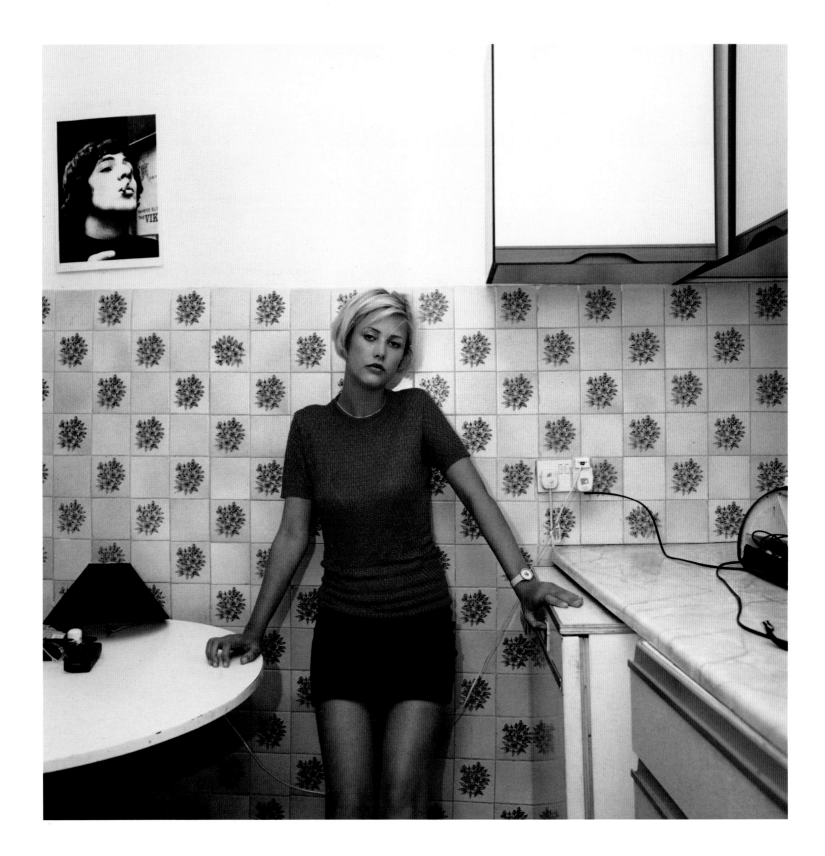

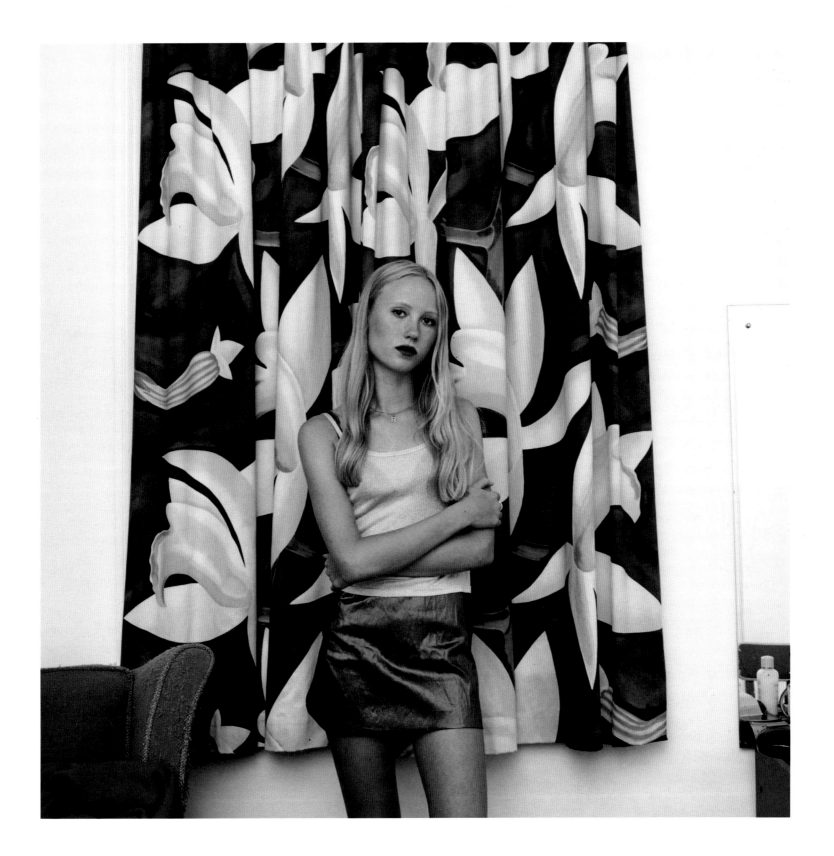

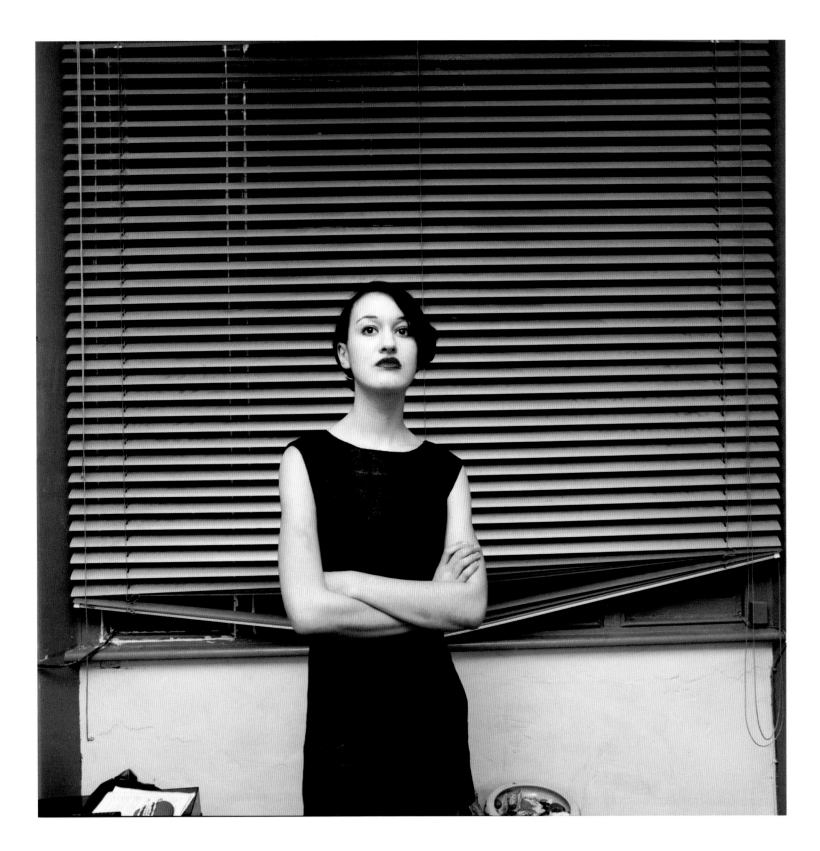

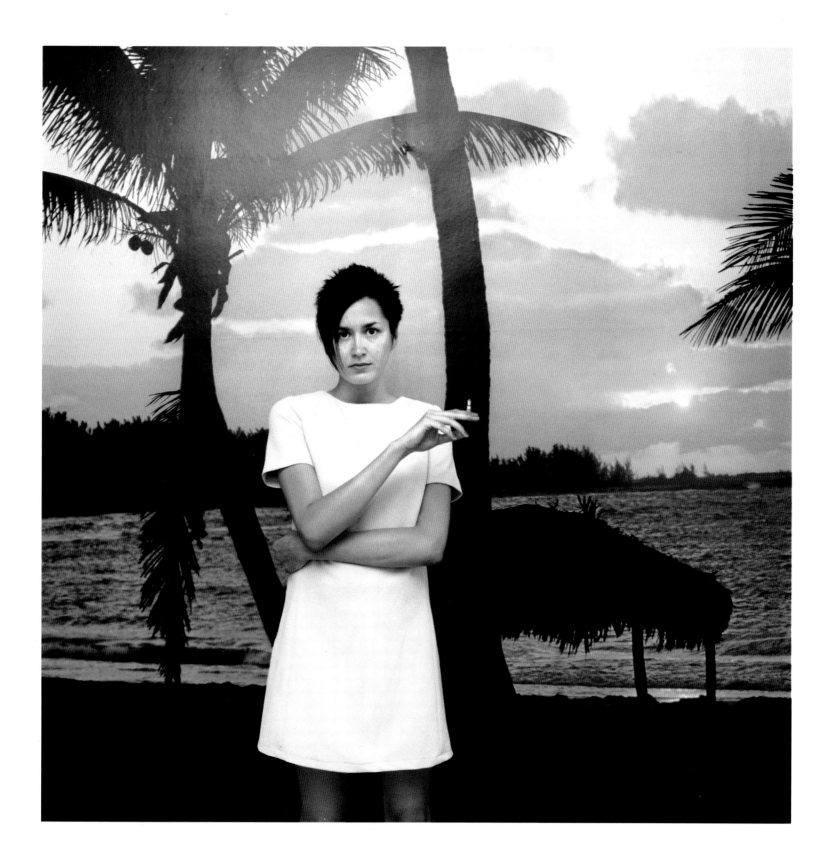

Q:how would you describe your work

A:the outcome of two people
putting their heads together
to create something that nobody
asked us to do

antoni & alison

portrait:paul coker

title:**kickin'**
indian ink and 'candy orange' emulsion on canvas
title:**in thing**
indian ink and 'pinky stone' emulsion on canvas
title:**hip**
indian ink and 'true blue' emulsion on canvas

title:**with it 77**
indian ink and 'fairyland' emulsion on canvas
title:**happening**
indian ink and 'butter cup' emulsion on canvas
title:**trendy**
indian ink and 'deco' emulsion on canvas
sign writing:**tat & whimsy** 1996

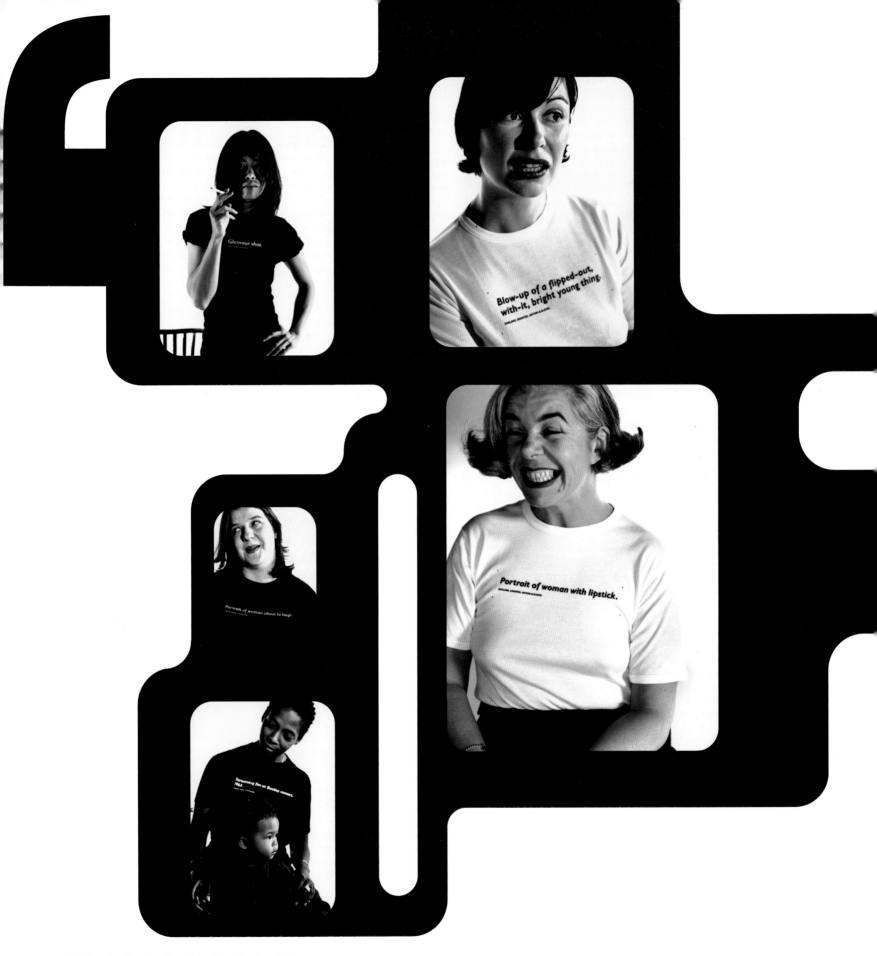

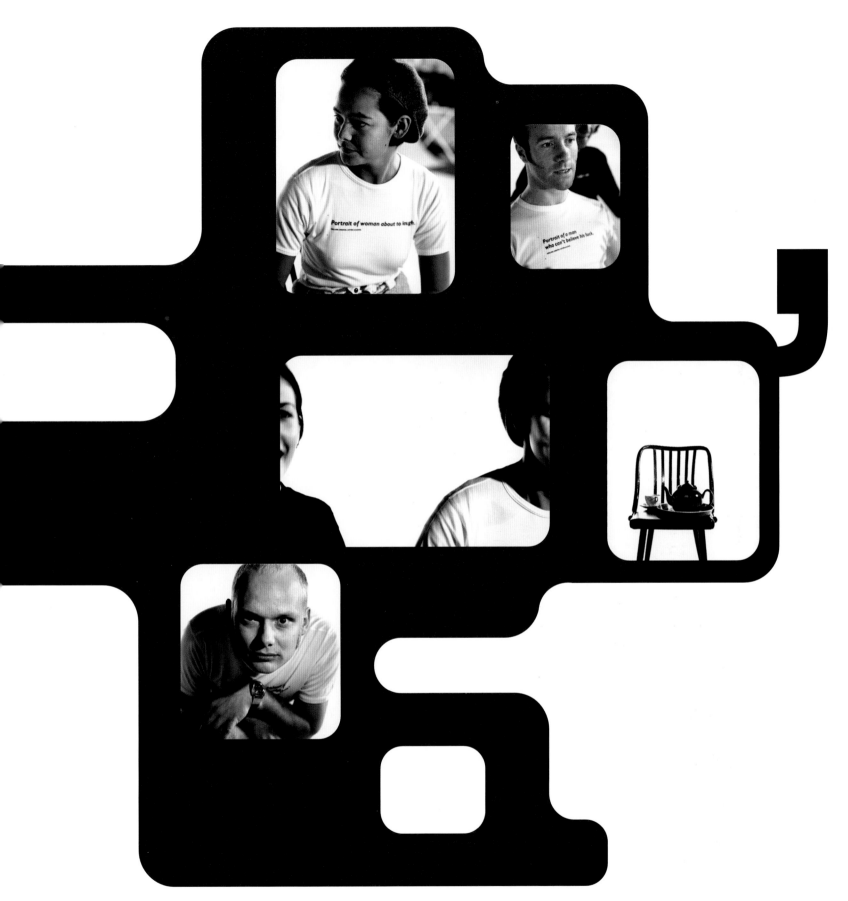

it's full of people cons
who don't realise that if
creating all the great thin
somewhere else to earn
is too cold. depending on
blow). london is important
(hussein chalayan). it's w
drugs and rock 'n' roll (a
anti-rom). what goes und
and fresher than the fish
guess i missed that one,
people. shame it does
bishop). good take-aw

it's delicious!

ntly moaning that they have no money
ey did have money, they wouldn't be there
they do. it's just a shame they have to go
big bucks. paris is too haughty. new york
time of year. london's cool (james pretlove,

terms of freedom of thought and tolerance
re all the energy stems from - music, sex,
kander mcqueen). nepotism (luke pendrell,
cover is so intelligent and raw - it's purer
ff felixstowe (nick griffiths). what scene...
ugh london is great, so full of talented
t offer them more opportunities (durrell

y food/tolerance/eccentricity (tomas
roope, anti-
rom).

Q:in what way is the british or london scene important to you

A:

high technology fabrics that respond to the needs of all-night clubbers. clothes that reflect the needs of non-mainstream groups. clothes that reflect the move away from the dressier styles of the late '80s. clothes that give a strong identity to a subculture. clothes that make the practical fashionable. clothes that blur lines of gender. fabrics with patterns that complete a night's dance experience. cheaper clothes affordable to more people.

clothes:**mickey brazil, guerillawear, hysteric glamour, komodo, maharishi, daniel poole, stüssy, surge, vexed generation**
selection:**michael oliveira-salac** text:**james pretlove**

label:**surge** design:**toby benjamin 1996**

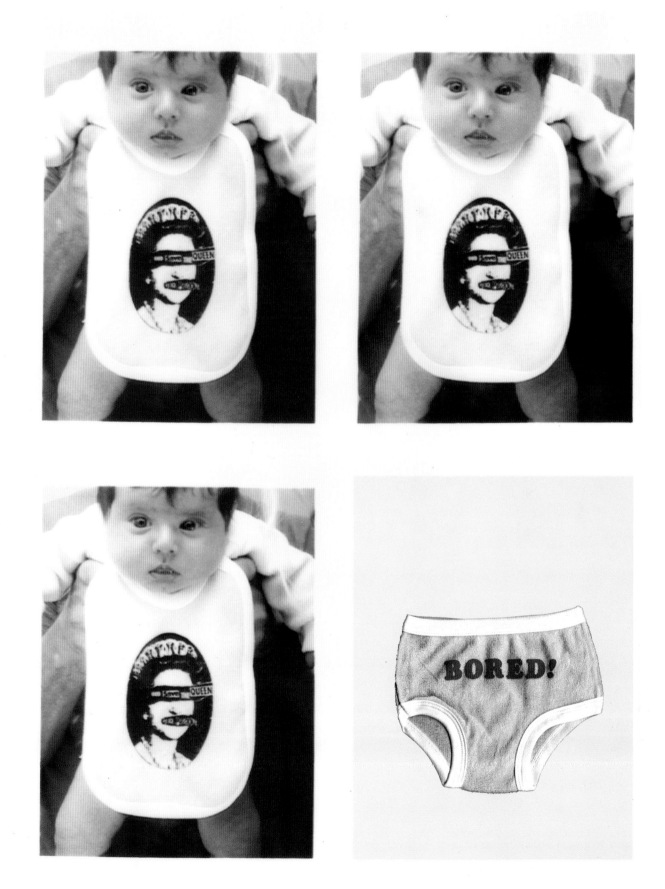

clothes:**punk baby bib+bored baby pants 83**
portobello market 1996
model:**nico-lou**

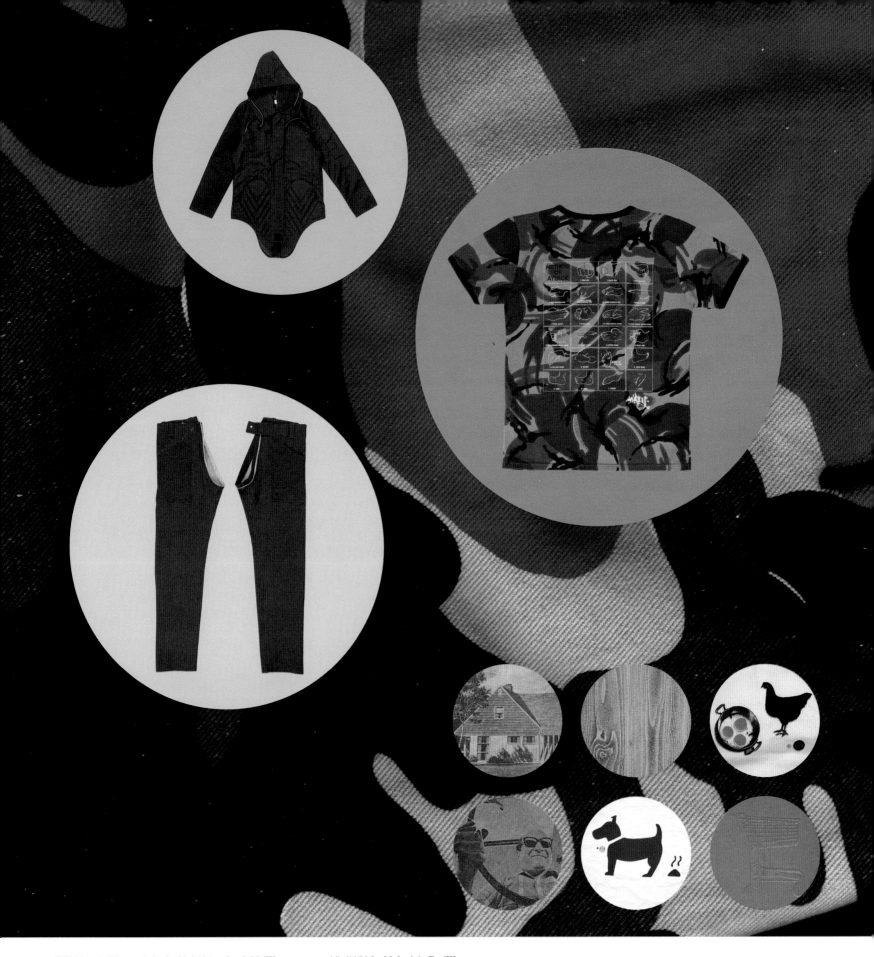

84 clothes:**striking points t-shirt** label:**maharishi 1996**

clothes:**zip crotch jeans** label:**mickey brazil 1996**
courtesy:**sign of the times**

clothes[details]: **t-shirts** design:**fly 1996**

clothes:**parka** label:**vexed generation 1996**

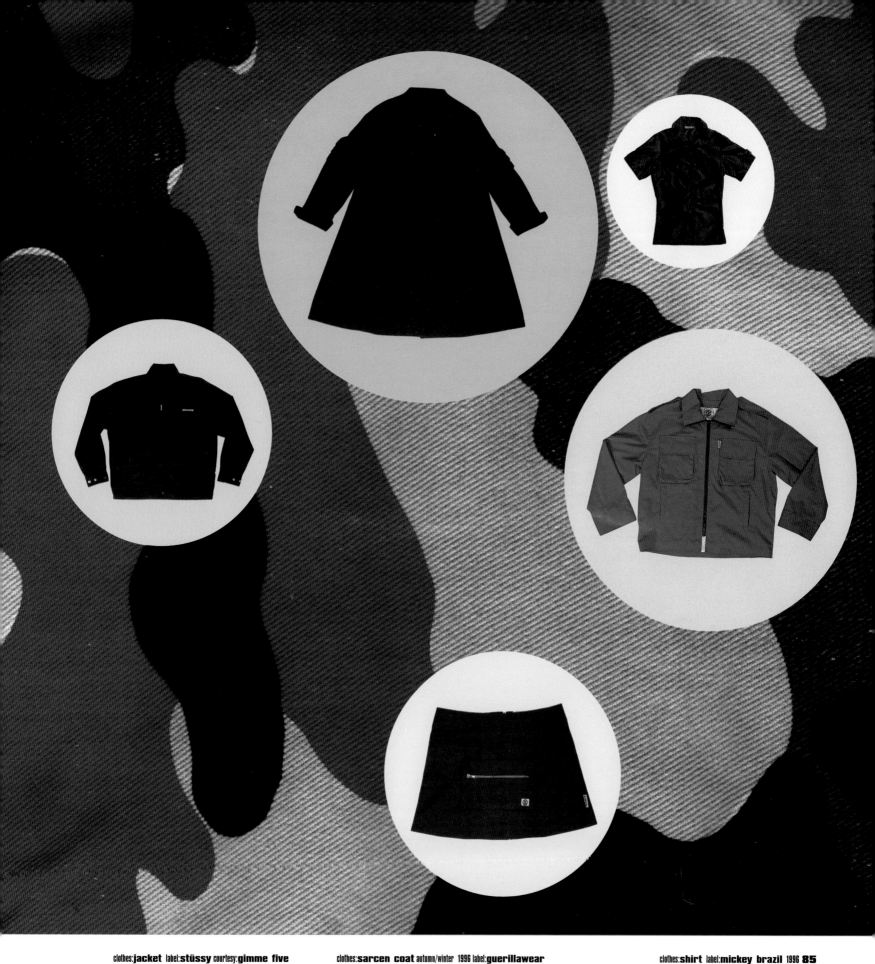

clothes:**jacket** label:**stüssy** courtesy:**gimme five**

clothes:**sarcen coat** autumn/winter 1996 label:**guerillawear**
design:**lee farmer**

clothes:**shirt** label:**mickey brazil** 1996 **85**
courtesy:**sign of the times**

clothes:**mini skirt** christmas collection 1996 label:**komodo**
design:**vanessa coyle** with assistance from theresa morris and lisa wright

clothes:**jacket** christmas collection 1996 label:**komodo**
design:**vanessa coyle** with assistance from theresa morris and lisa wright

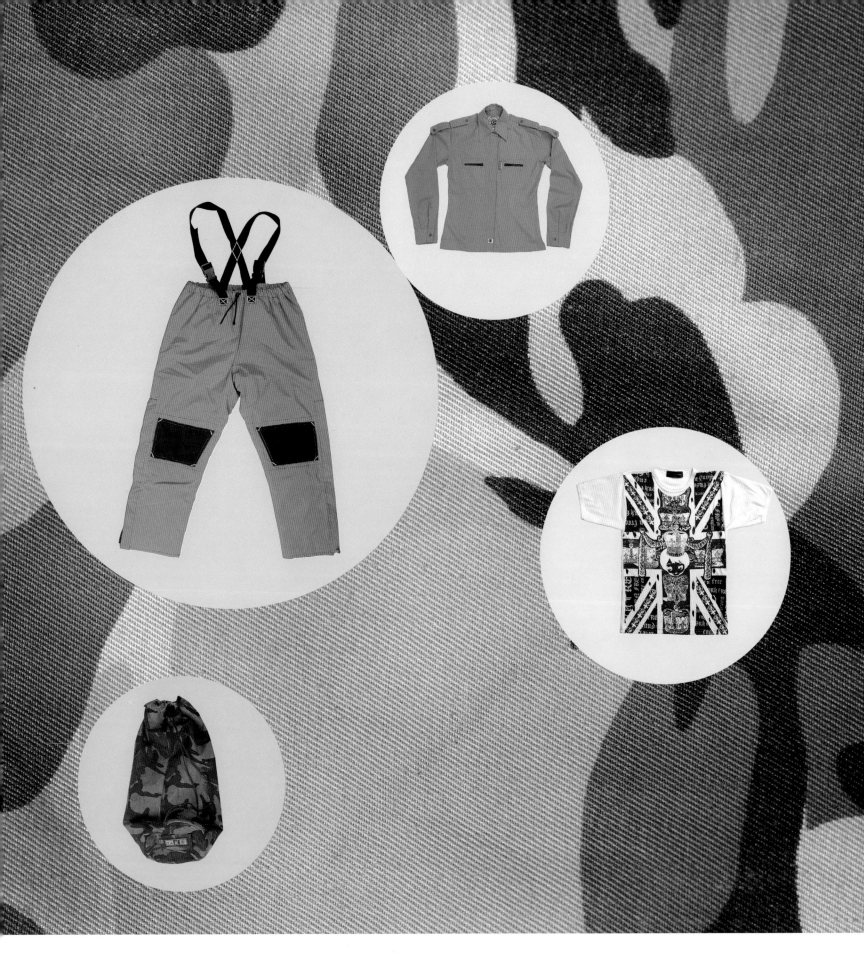

86 clothes and accessories:**re-styled british telecom workwear
+combat duffle bag** 1996 label:**maharishi**

clothes:**zip shirt** label:**komodo** design:**vanessa coyle**
with assistance from theresa morris and lisa wright 1996

clothes:**t-shirt** label:**born free** at sign of the times 1996
courtesy:**sign of the times**

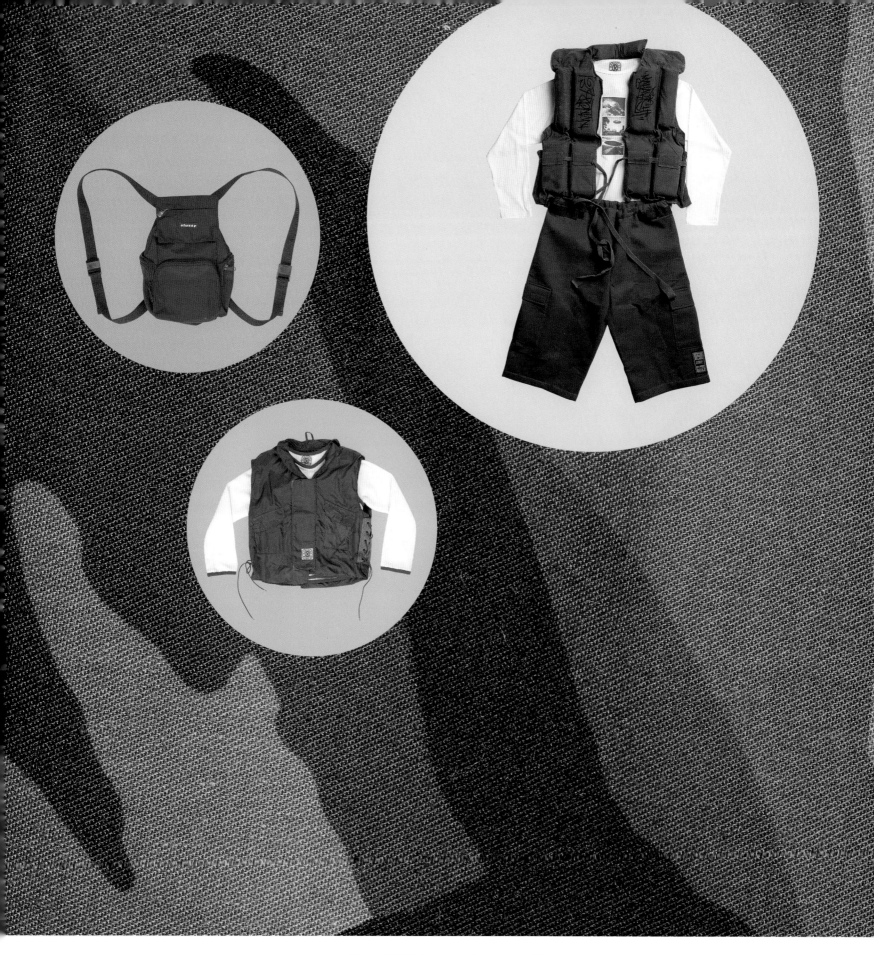

clothes:**combat life-jacket, skate pants+t-shirt**
labels:**maharishi+komodo**

accessory:**rucksack** label:**stüssy** courtesy:**gimme five 87**

clothes:**fleecy top and military-style waistcoat**
label:**komodo** design:**vanessa coyle**
with assistance from theresa morris and lisa wright 1996

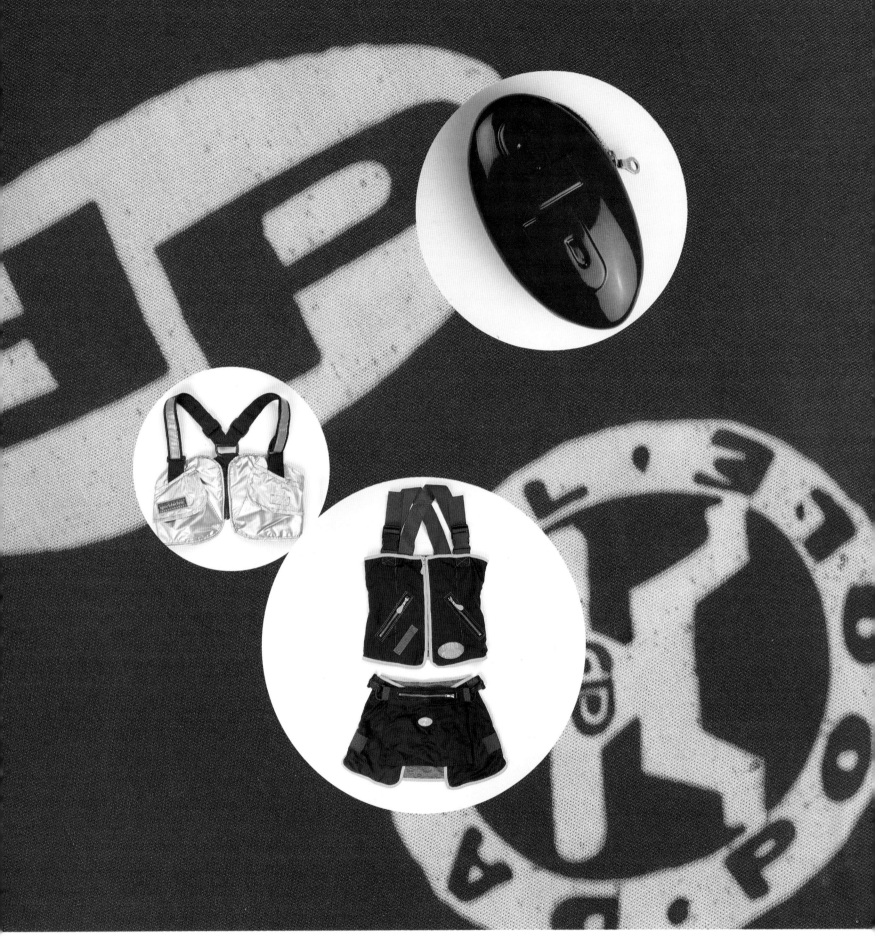

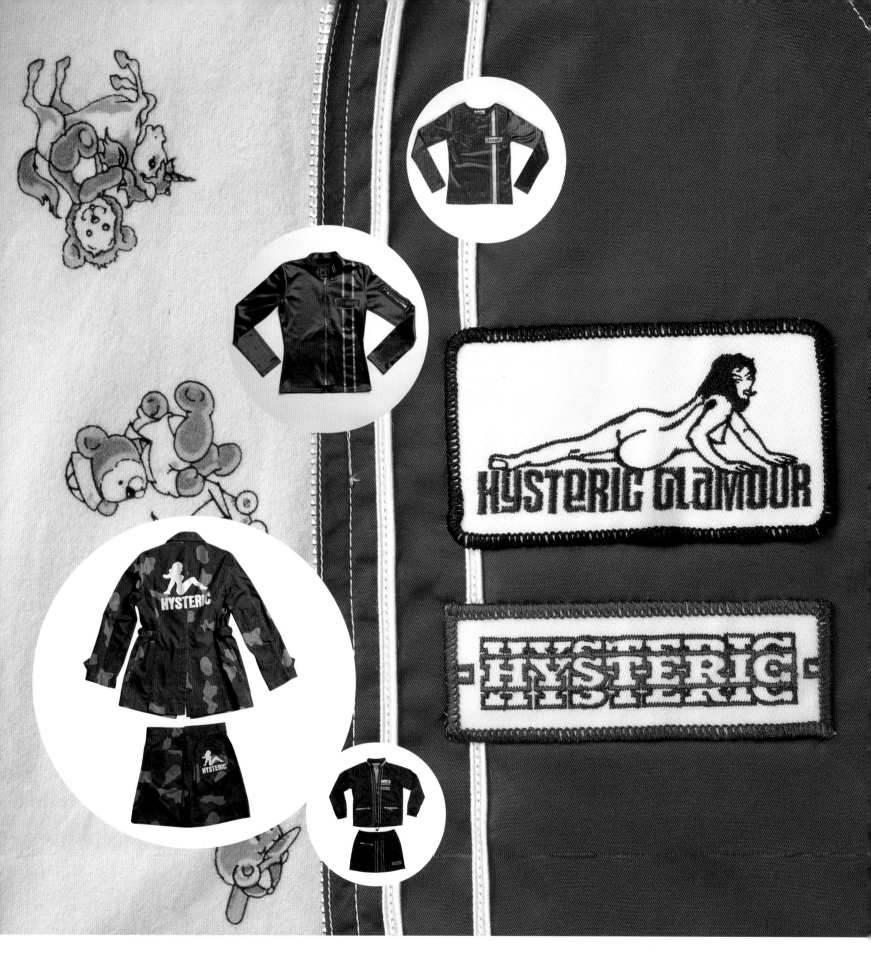

Q:jeremy, how would you describe your work. A:my work is based around fashion, music and youth culture.
Q:nick, how would you describe your work. A:inspecting the situation - creative scheming - fixing things.

portrait:paul wetherell

jeremy murch
styling:**nick griffiths**

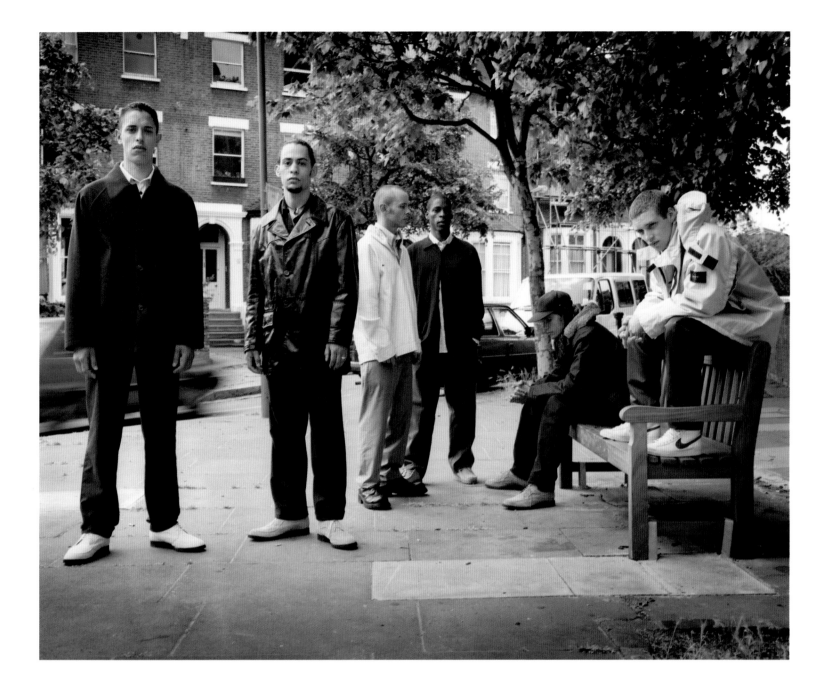

clothes:**adidas, celine, christian la croix,**
cp company, dalston market,
duffer of st george, hackett, hush puppies,
issey miyake, joelynian, joy steps, nike,
portobello road market, sisley, stone island,
valentino, yves saint laurent
hair:**adam meli** make-up:**emma kotch**
models:**aiden, colin, edward, george, julian, justine,**
remi at take two, **ingrid** at boss, **miranda, annabelle** at select,
danielle at models one
sponsors:**l.t.i** (processing), **the pro centre** (equipment hire) **91**

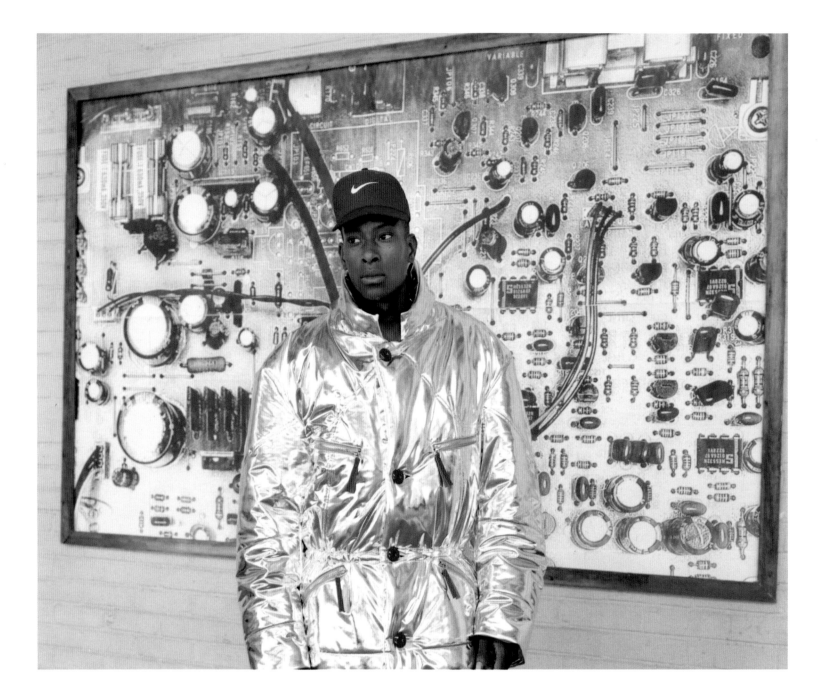

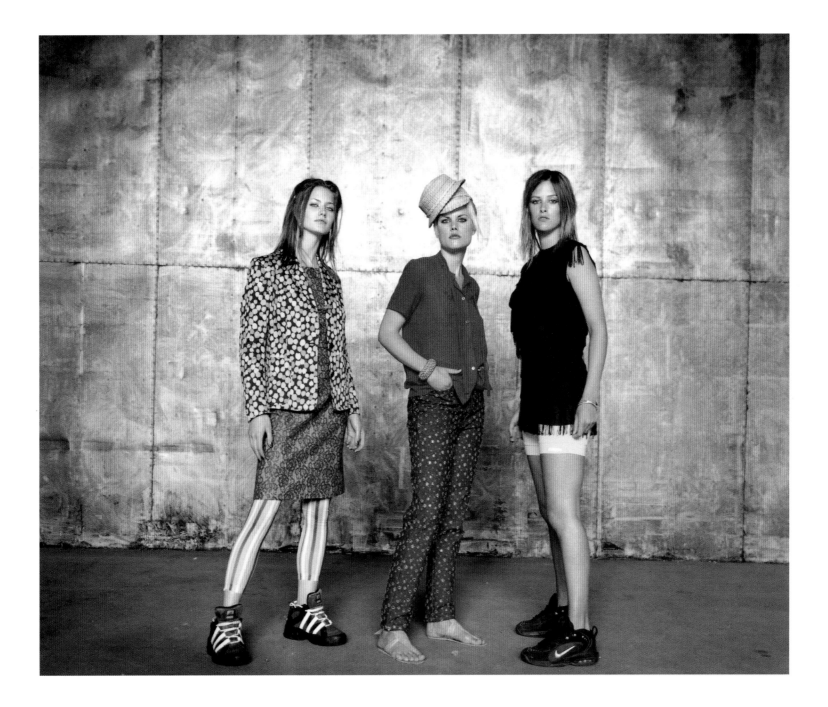

the midnight in the of

contemporary concepts

Q: what do you value most in the creative sphere

A:

ours between
ht and 5.00
morning (brian
britain)

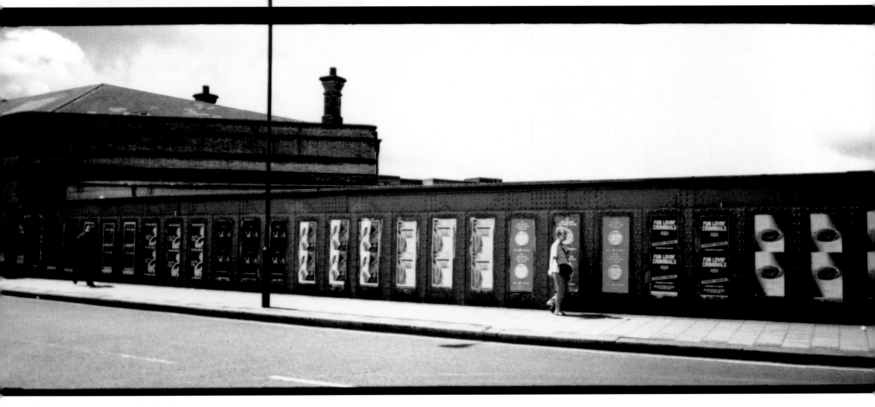

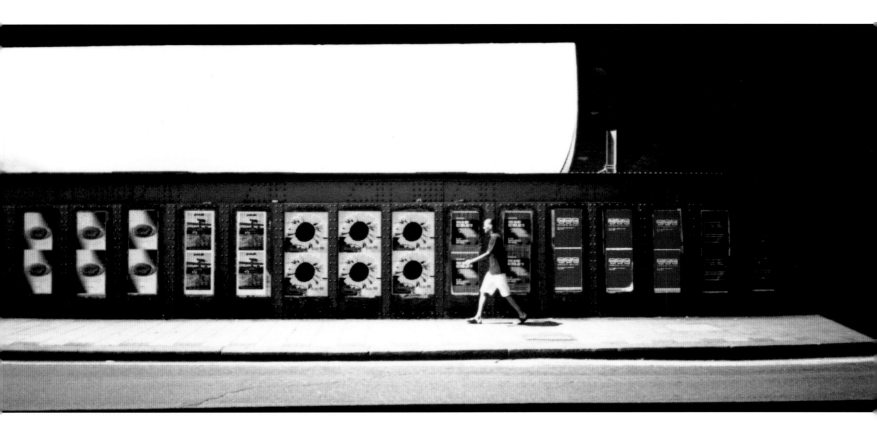

title:**posterwall 97**
site:**westbourne park tube** 29.07.96
photograph:**fabian monheim**

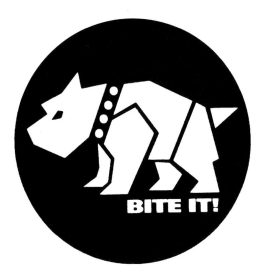

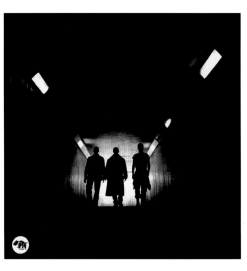

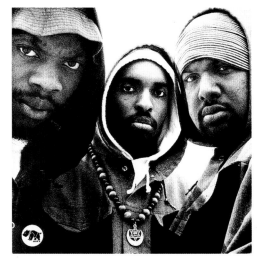

photographs:**donald christie**
design and art direction:**trevor jackson**

artist:**the brotherhood** title:**xx111**
label:**bite it!** 1994

artist:**scientists of sound**
title:**scientists of sound ep**
label:**bite it!** 1992

artist:**the brotherhood**
title:**alphabetical response/one 3**
label:**bite it!/virgin** 1995

artist:**100% proof**
title:**different neighbourhood**
label:**bite it!** 1992

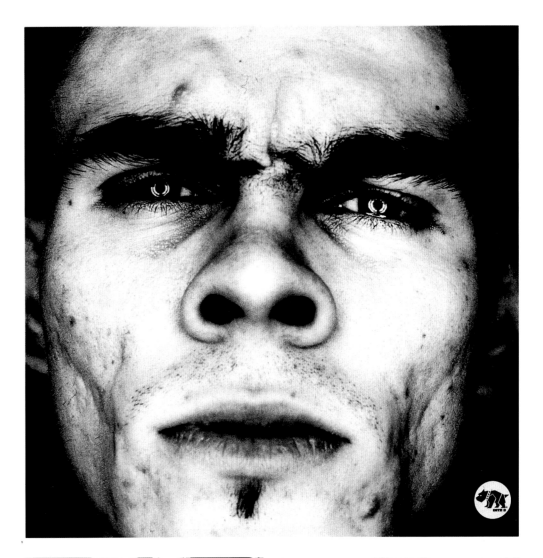

artist:little pauly ryan
title:make em go ooooh!/
little p fills the room up
label:bite it! 1993

artist:the brotherhood
title:wayz of the wize
label:bite it! 1992

artist:scientists of sound
label:bite it! 1994

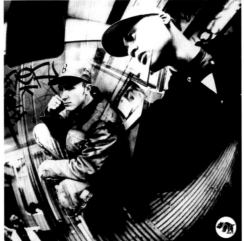

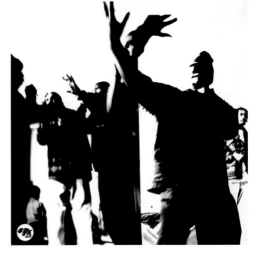

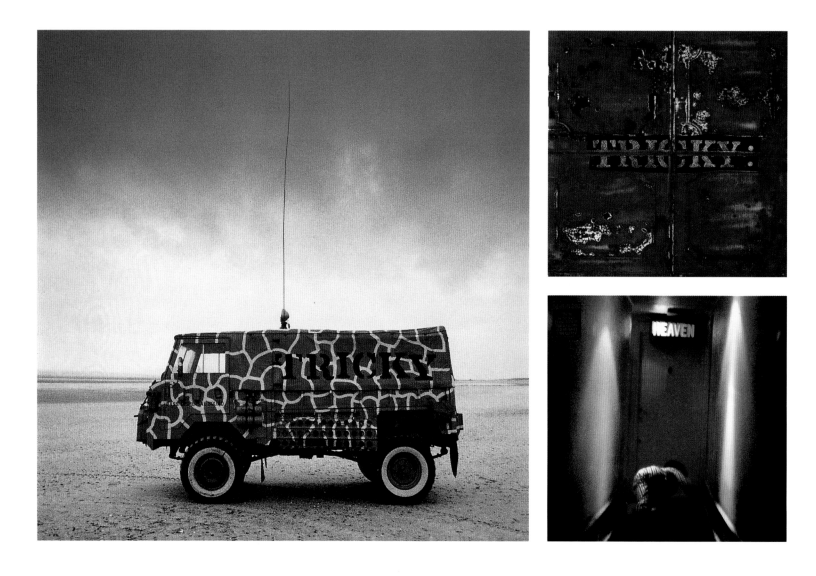

artist:**tricky** title:**maxinquaye** label:**island**
art direction and design:**cally** at art island
photographs:**andy earl, valerie phillips + cally** 1994

artist:**nearly god** title:**heaven** label:**island**
sleeve concept:**tricky** design and art direction:**cally** at art island
photograph:**mia lucas** 1996

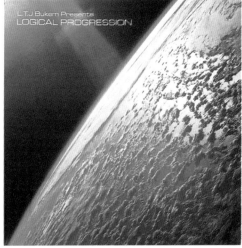

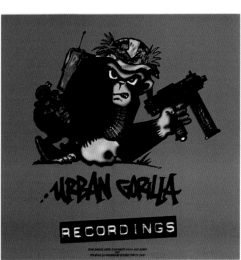

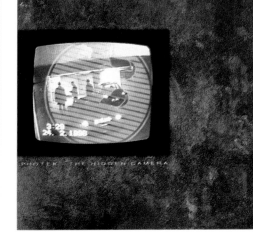

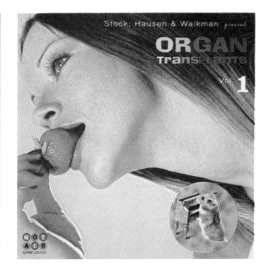

artist:**conqueror**
title:**crown jewels featuring mc det**
label:**kickin** 1995

artist:**urban gorilla recordings** label:**labello**
design:**dave nodz, james low+andy swallow** 1995

artist:**wafta** title:**college street zoo** label:**spymania**
design:**wafta+mat consume**
photograph:**ed hepburne scott** 1996

artist:**photek** title:**the hidden camera**
label:**virgin** design:**mark standere** 1996

artist:**olive** title:**miracle** label:**bmg**
design:**peter chadwick** at zip design 1996

artist:**ljt bukem** title:**logical progression**
label:**london records** design:**blue room** 1996

artist:**stock, hausen & walkman**
title:**organ transplants volume one** label:**hot air**
design:**andrew sharpley, matthew ward
+andi chapple** 1996

artist:**squarepusher** title:**feed me weird things**
label:**rephlex** design:**tom jenkinson+johnny clayton** 1996

Q:how would you describe your work
A:passionate, physical, emotional.

 phil knott

title:**neneh cherry**

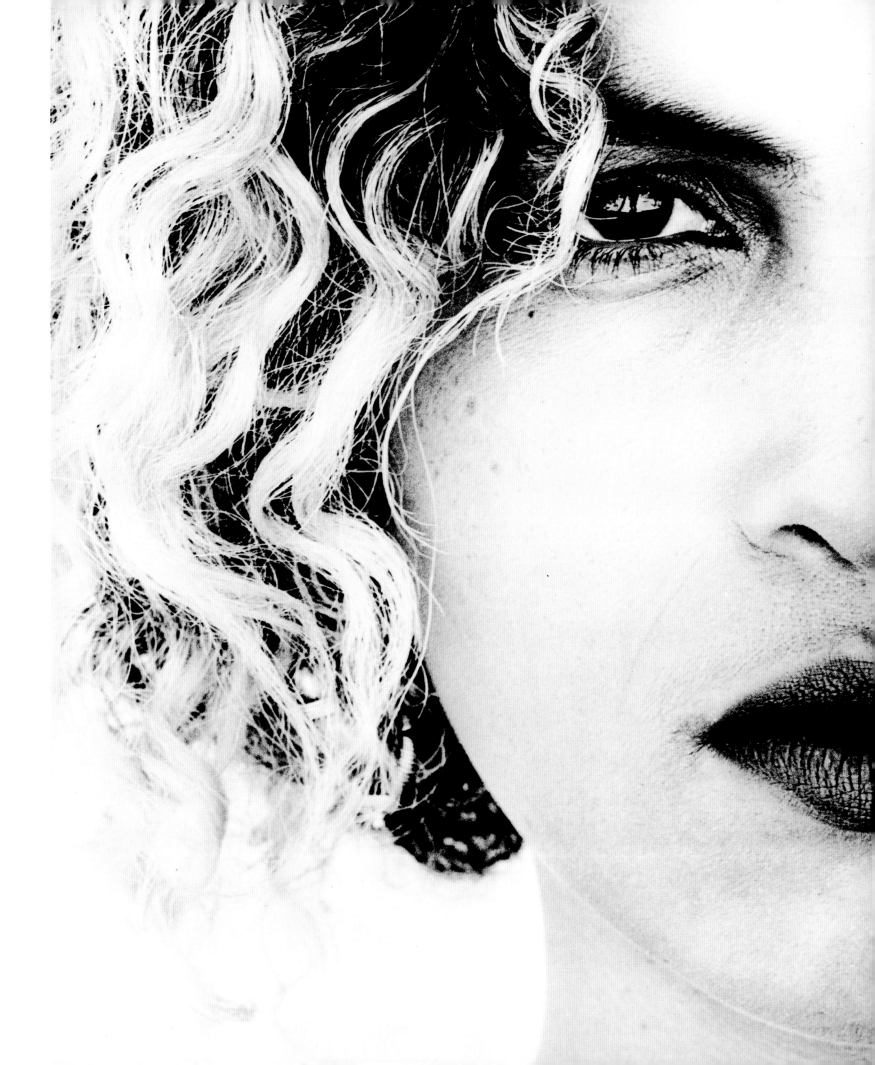

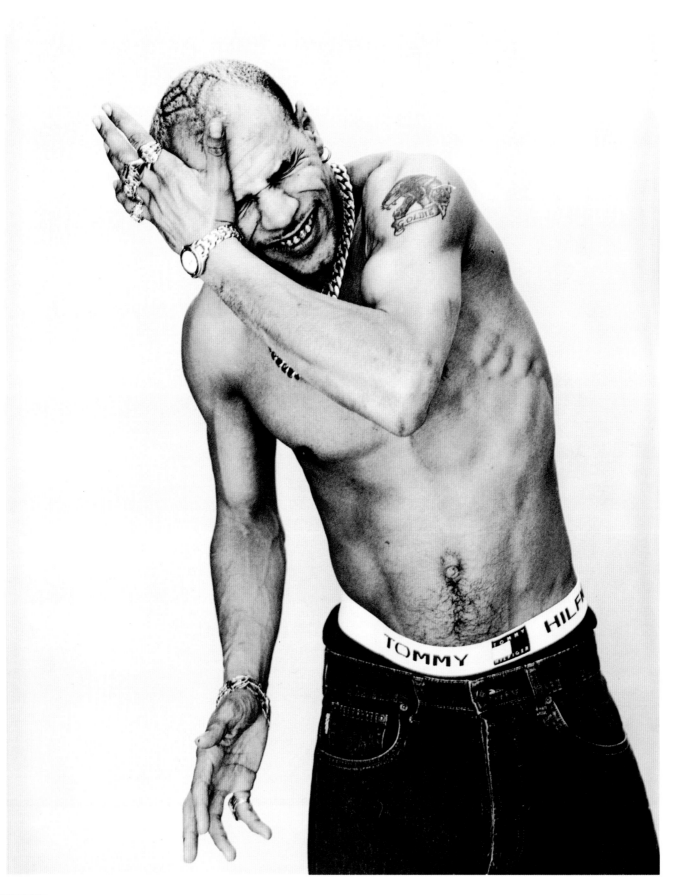

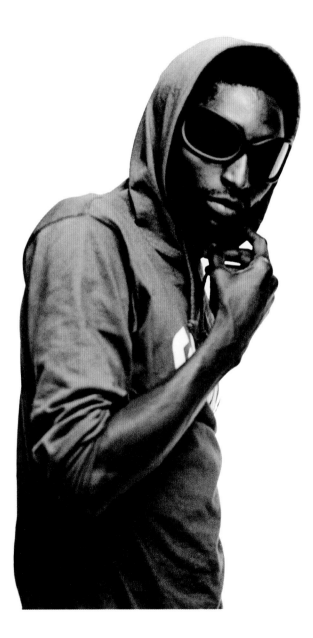

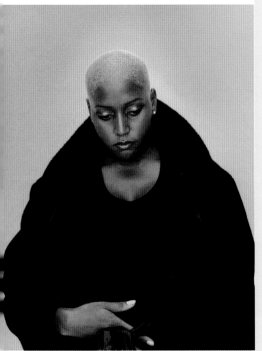
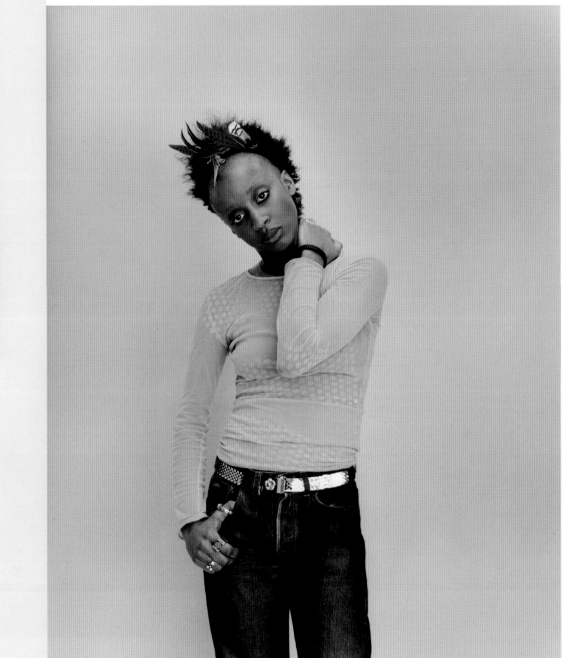

106 title (left):mica paris
title (centre):zoe
title (right):alex of acacia

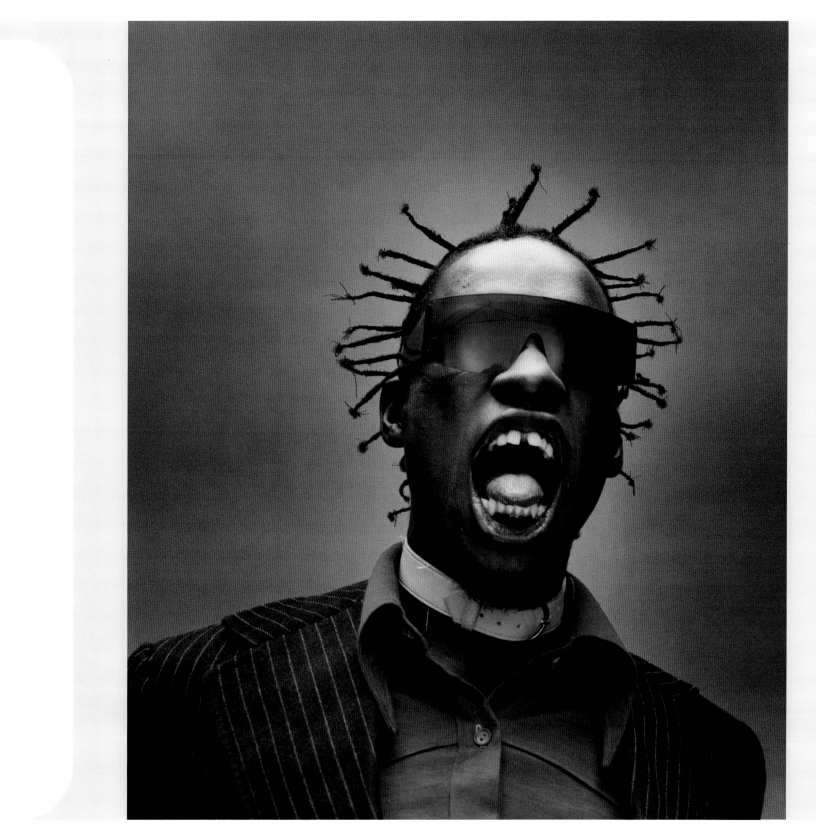

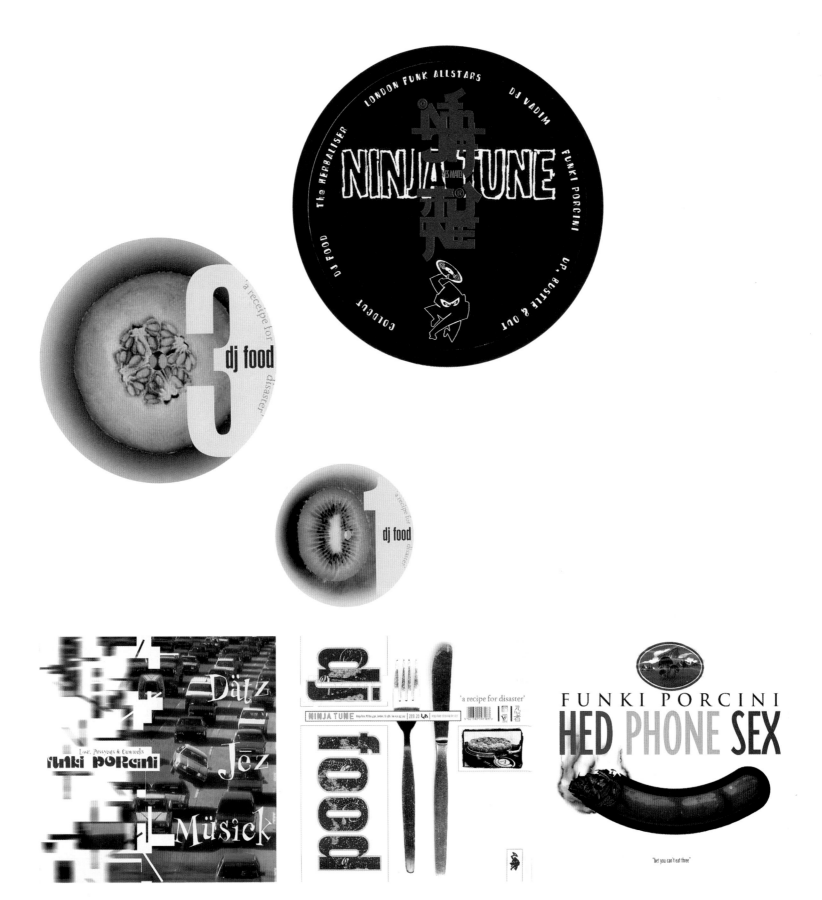

artist:**funki porcini**
title:**love, pussycats and carwrecks**
label:**ninja tune** design:**openmind** 1996

artist:**dj food** title:**a recipe for disaster**
label:**ninja tune** design:**openmind** 1995

artist:**funki porcini** title:**hed phone sex**
label:**ninja tune** design:**openmind** 1995

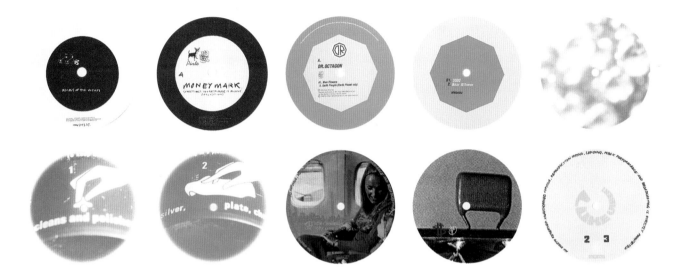

project:**mo wax labels+sticker**

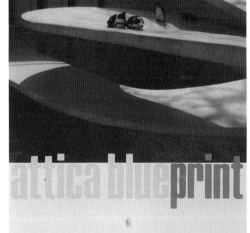

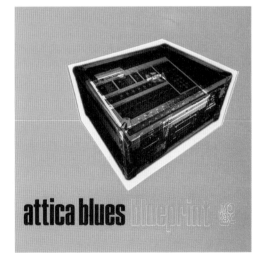

artist:**sam sever and the raiders of the lost art**
title:**what's that sound?**
label:**mo wax** photograph:**will bankhead** 1995

artist:**attica blues** title:**blueprint** label:**mo wax**
design:**ben drury+will bankhead** 1995

artist:**attica blues** title:**blueprint** label:**mo wax**
design:**ben drury+will bankhead** 1995

BASSHEADS IS THERE ANYBODY OUT THERE?

FELIX DON'T YOU WANT ME

HED BOYS GIRLS & BOYS

title:**deconstruction classics**
photographs:**christopher griffiths**
design:**mark farrow design** 1995

wreckage inc. *salvage*

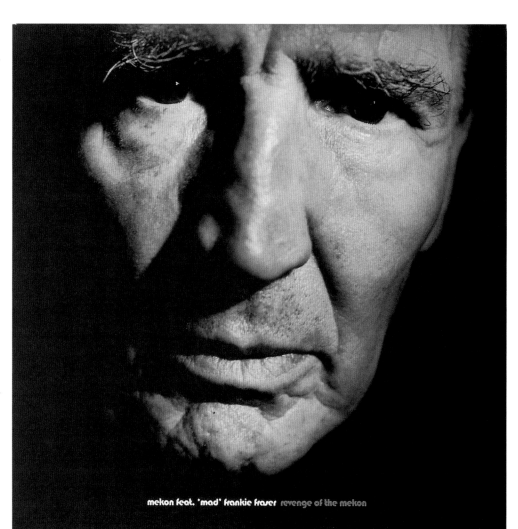

mekon feat. 'mad' frankie fraser *revenge of the mekon*

the wiseguys feat. sense live *the sound you hear / we keep on*

110 artist:**wreckage inc** title:**salvage**
 label:**wall of sound** photograph:**chris clunn**
 design:**peter barrett+andrew biscomb** 1996

artist:**the wise guys featuring sense live**
title:**the sound you hear+we keep on**
label:**wall of sound** photograph:**chris clunn**
design:**peter barrett+andrew biscomb** 1996

artist:**mekon featuring mad frankie fraser**
title:**revenge of the mekon**
label:**wall of sound** photograph:**chris clunn**
design:**peter barrett+andrew biscomb** 1996

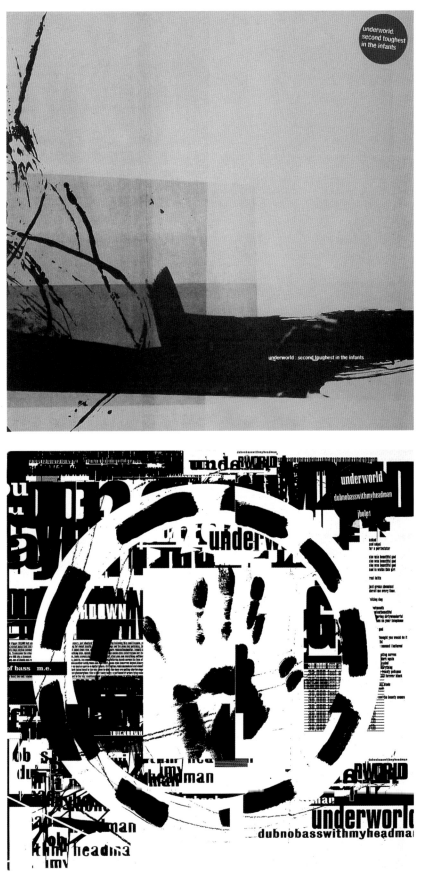

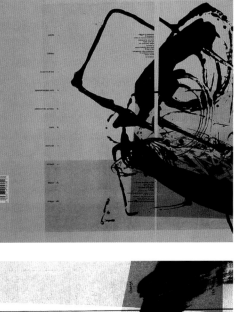

underworld:
second toughest
in the infants

underworld : second toughest in the infants

artist:**underworld**
title:**second toughest in the infants** 1996
title:**dubnobasswithmyheadman** 1993
label:**junior boys own** design:**tomato**

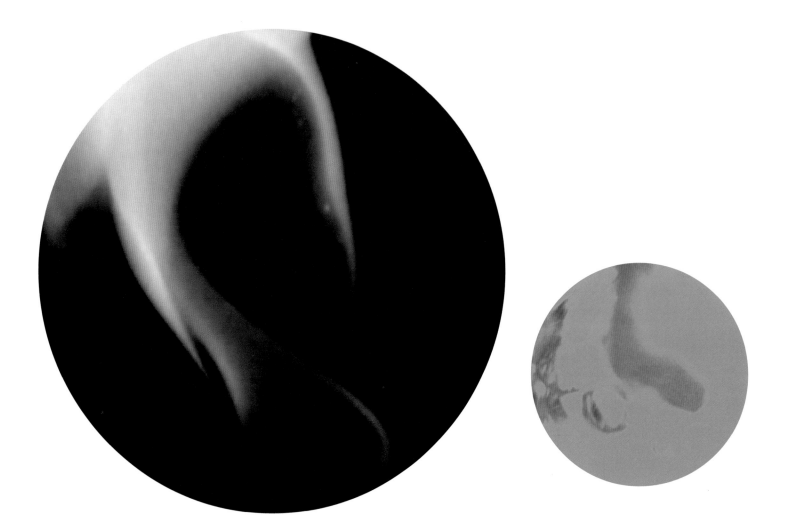

Tomato has been in existence since 1991. Not a company in the conventional sense, nor an orthodox collective, instead Tomato is a space within which the eight members meet to collaborate, compare experiences and make new work.

Because Tomato operates as a cross between a space and a support structure, those involved in the group are able to collaborate or work individually as they see fit, depending on the demands of the task. This means that the approach within Tomato is not about design in any traditional sense, instead Tomato make work which is, where possible, changed and adapted to peoples' differing needs and contexts. If anything, Tomato is a system, a structure and a framework.

Q:how would you describe your work. van dooren baker wood warwicker

kedley

taylor

smith + hyde A:a robe made of myth, a puma made of pickle.

title:**personal project- 113**
in the outside 1996

title:**personal project -**
green light 1996
medium:grabs from video sequences

a precise
moment

a change

title:**personal project 115**
- windfall 1996

title:**personal project**
- point 1996
medium:grabs from video sequences

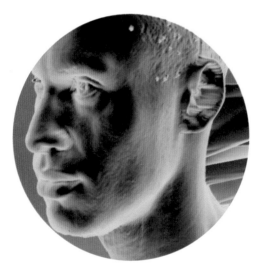

buggy g riphead

Q:how would you describe your work. A:image poetry.

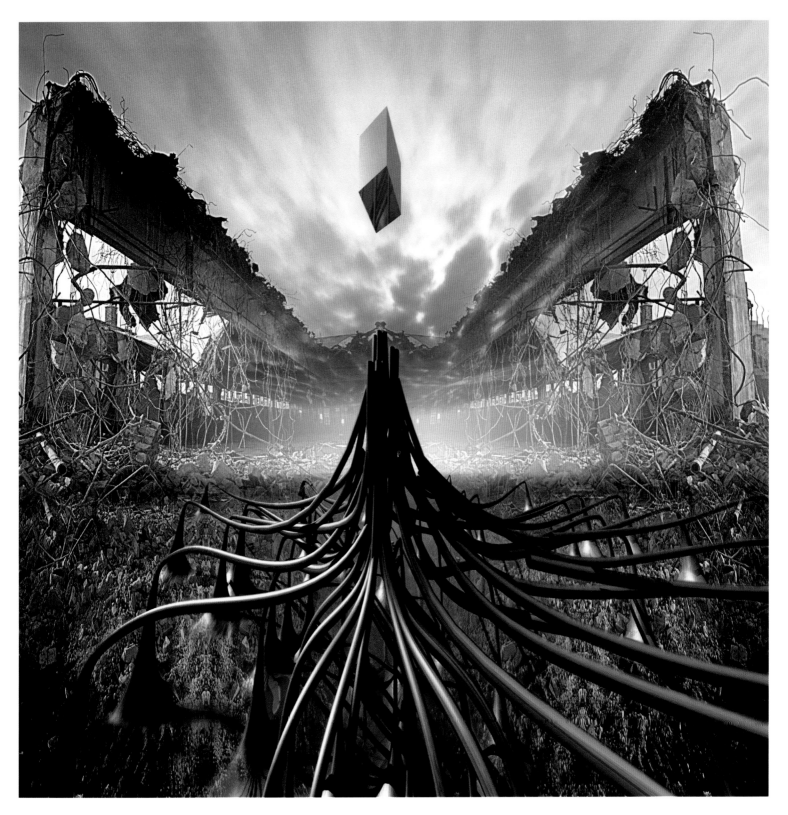

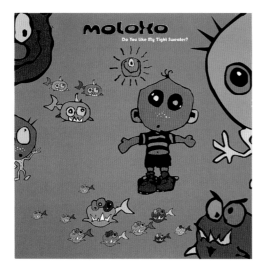

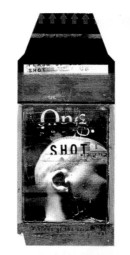

artist:**moloko** title:**do you like my tight sweater?**
label:**the echo label** design:**the designers republic** 1995

artist:**the brotherhood** title:**one shot**
label:**bite it!/virgin**
design and photograph:**dave mckean** at hourglass 1996

title:**below volume two** label:**beechwood music**
design:**think electric** 1995

artist:**tortoise** title:**djed** label:**city slang**
design:**subterrain design workshop** 1996

artist:**forces of nature** title:**dimensions**
label:**clean up** 1996

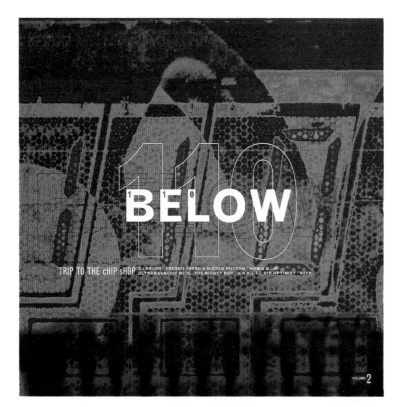

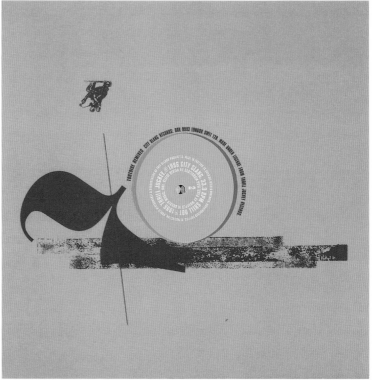

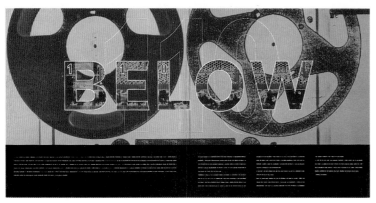

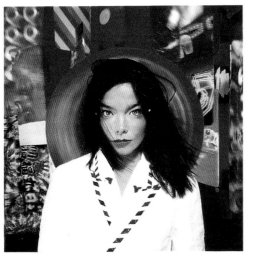

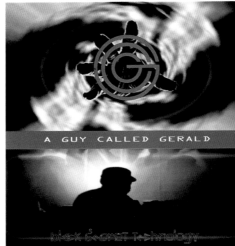

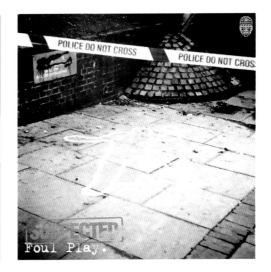

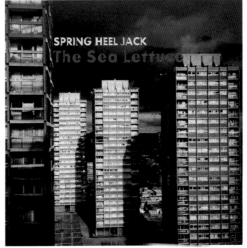

artist:**björk** title:**post** label:**one little indian**
photograph:**sephane sednaoui** clothes:**hussein chalayan**
design:**me company** 1995

artist:**various** title:**there are many different colours**
label:**octopus recording** design:**gagartichoke** 1996

artist:**a guy called gerald**
title:**black secret technology**
label:**juice box** design:**david morgan** at b2 1995

artist:**alex reece** title:**feel the sunshine remixes**
label:**island** design:**simon emery** 1996

artist:**spring heel jack** title:**sea lettuce**
label:**rough trade** photograph:**ashley wales**
design:**yuki miyake** at system gafa 1994

artist:**moving shadow** title:**foul play suspected**
label:**moving shadow music** design:**sean o'keeffe** 1995

title:**new renaissance mix collection part three**
label:**renaissance**
design:**rob petrie+phil sims** at dolphin 1996

artist:**anthony manning** title:**elastic variations**
label:**irdial discs** sleeve design:**marchant etrian** 1989
label design:**anthony manning** 1994

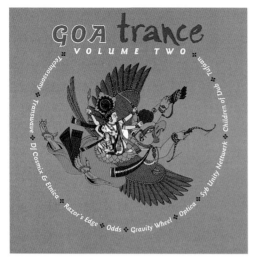

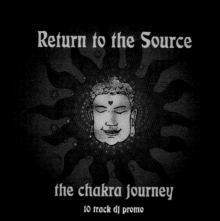

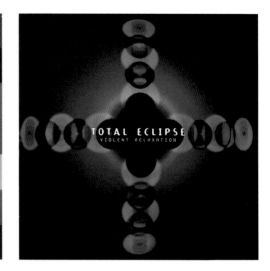

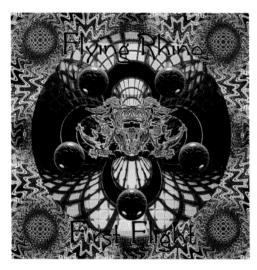

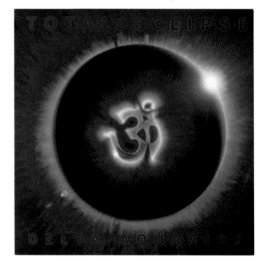

title:**goa trance volume two**
label:**rumour** illustration:**chris west** 1996

artist:**flying rhino** title:**first flight**
label:**flying rhino** design:**mark neal** 1996

title:**cream anthems** label:**deconstruction**
design:**mark farrow** with penny holton at touch 1995

title:**return to the source/buddha**
label:**pyramid** original design:**chris deckker** 1994

title:**celtic** label:**choci's chewns** 1996

artist:**the gentle people** title:**journey**
label:**rephlex** design:**johnny clayton** 1995

artist:**total eclipse** title:**violent relaxation**
label:**blue room** design:**simon ghahary** at blue room 1996

artist:**robert miles** title:**children** label:**deconstruction**
computer art:**william latham** 1996

artist:**total eclipse** title:**delta aquarids** label:**blue room**
design:**simon ghahary** at blue room 1994

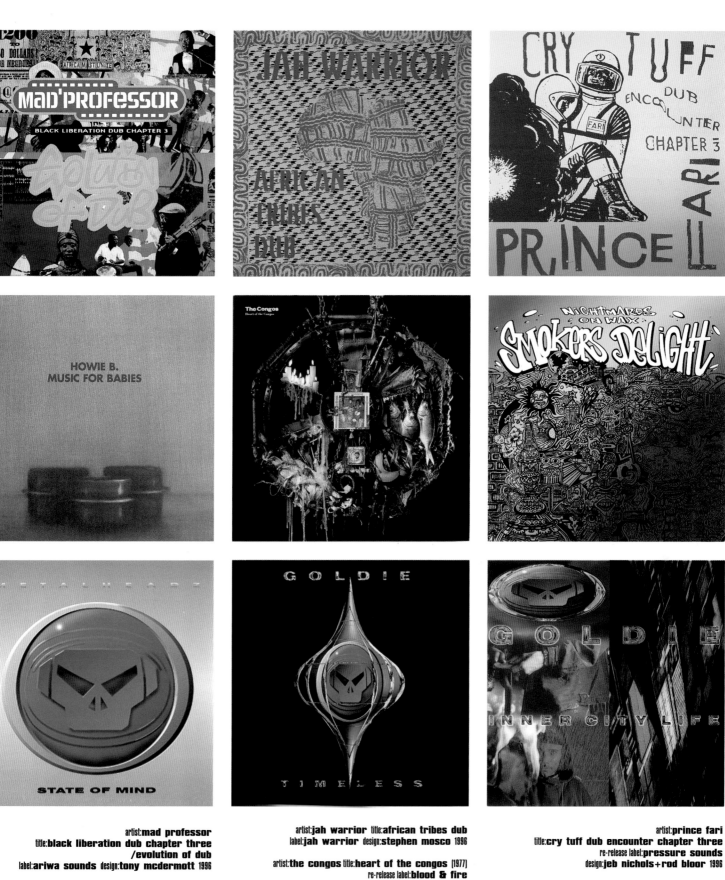

artist:**mad professor**
title:**black liberation dub chapter three**
/evolution of dub
label:**ariwa sounds** design:**tony mcdermott** 1996

artist:**howie b** title:**music for babies** label:**polydor**
design:**toshio nakanishi** 1996

artist:**goldie** title:**state of mind**
label:**metalheadz/london records**
design:**green ink+goldie** 1996

artist:**jah warrior** title:**african tribes dub**
label:**jah warrior** design:**stephen mosco** 1996

artist:**the congos** title:**heart of the congos** (1977)
re-release label:**blood & fire**
design:**mat cook** at introphotographs 1996

artist:**goldie** title:**timeless** label:**london records**
design:**green ink+goldie** 1995

artist:**prince fari**
title:**cry tuff dub encounter chapter three**
re-release label:**pressure sounds**
design:**jeb nichols+rod bloor** 1996

artist:**nightmares on wax** title:**smokers delight** label:**warp**
design: **leigh kenny (red)+lee mcmillan (monkee)** 1995

artist:**goldie** title:**inner city life** label:**ffrr**
design:**sam bennett** at green ink+**goldie**

A:for me to produce work is enough. if it's any good that's brilliant. but I'm not really worried about what people think of it.

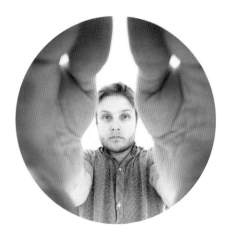

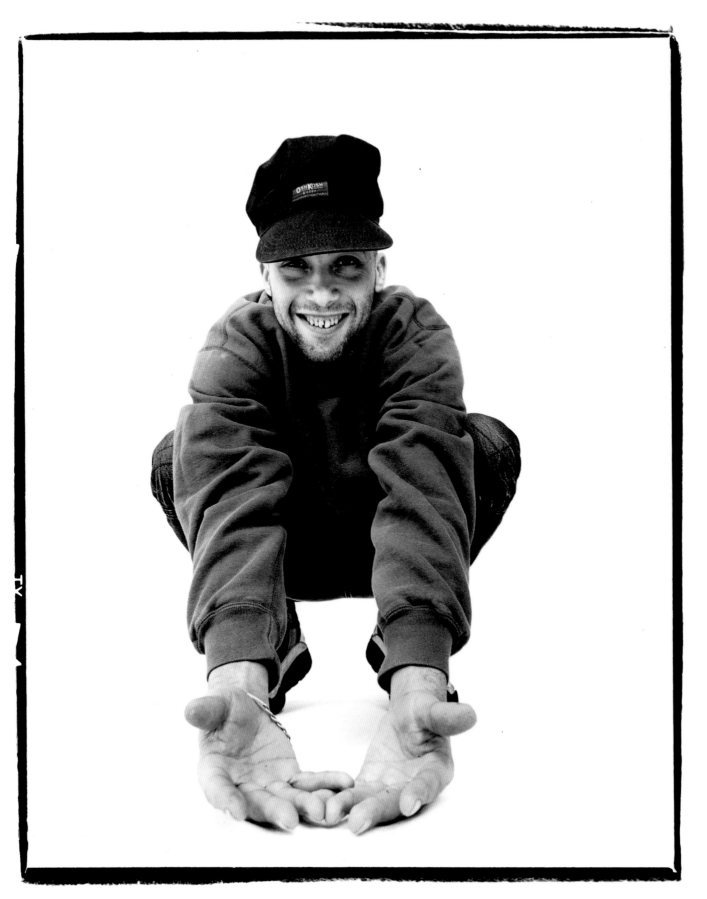

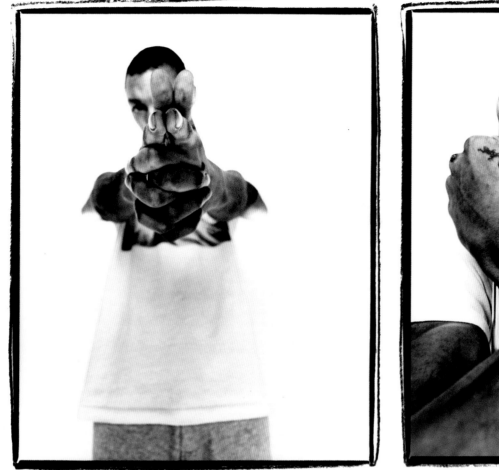
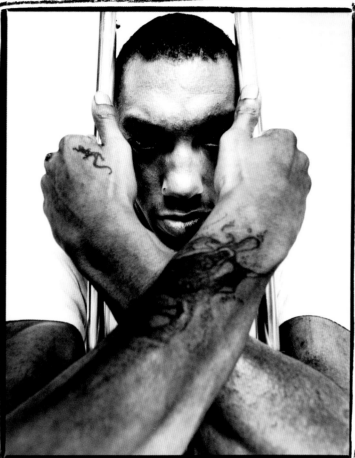

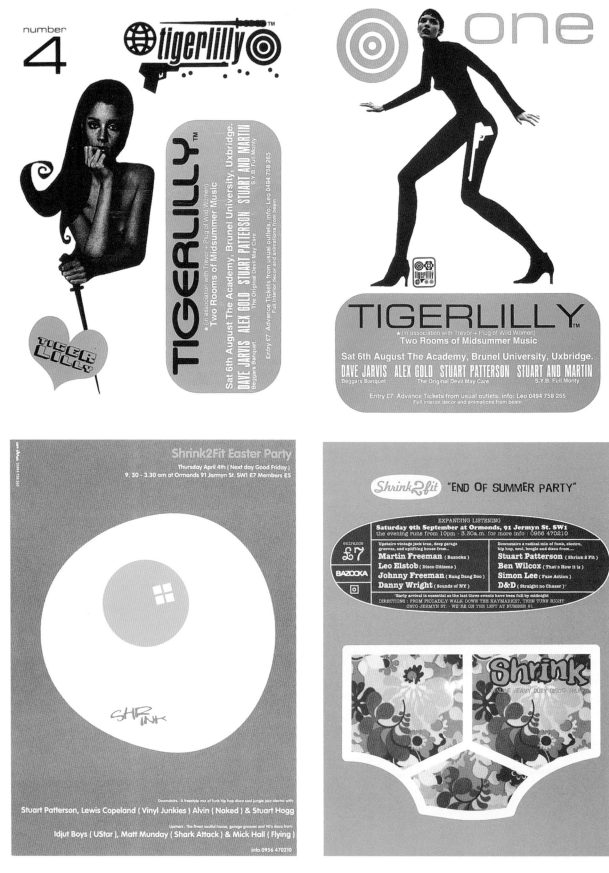

project:**flipbook flyer 129**
promoter:**pushca**
illustrations:**jason brooks** 1994

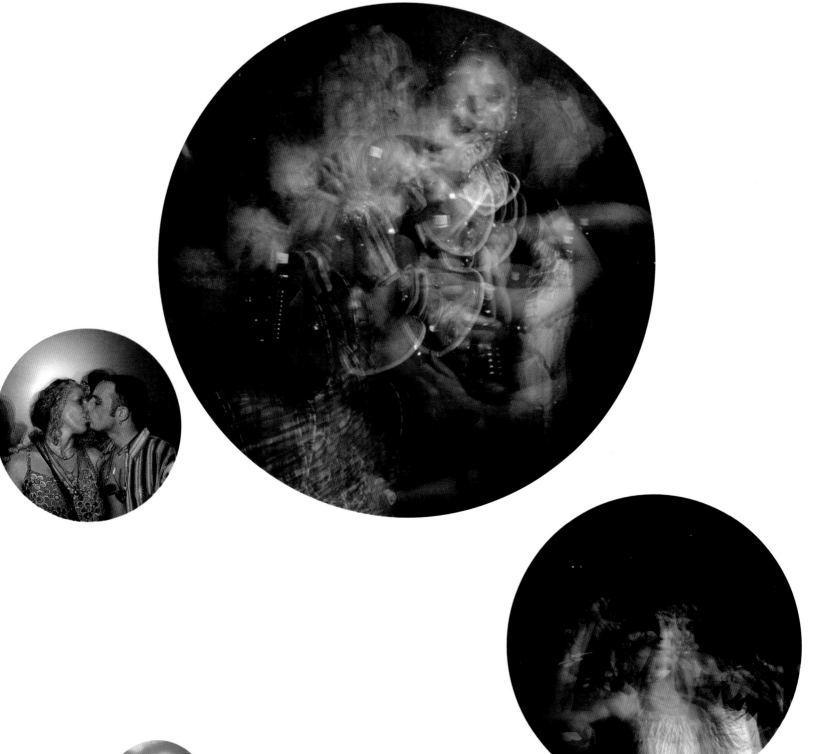

Q:how would you describe your work. A:photography for entertainment and surprise.

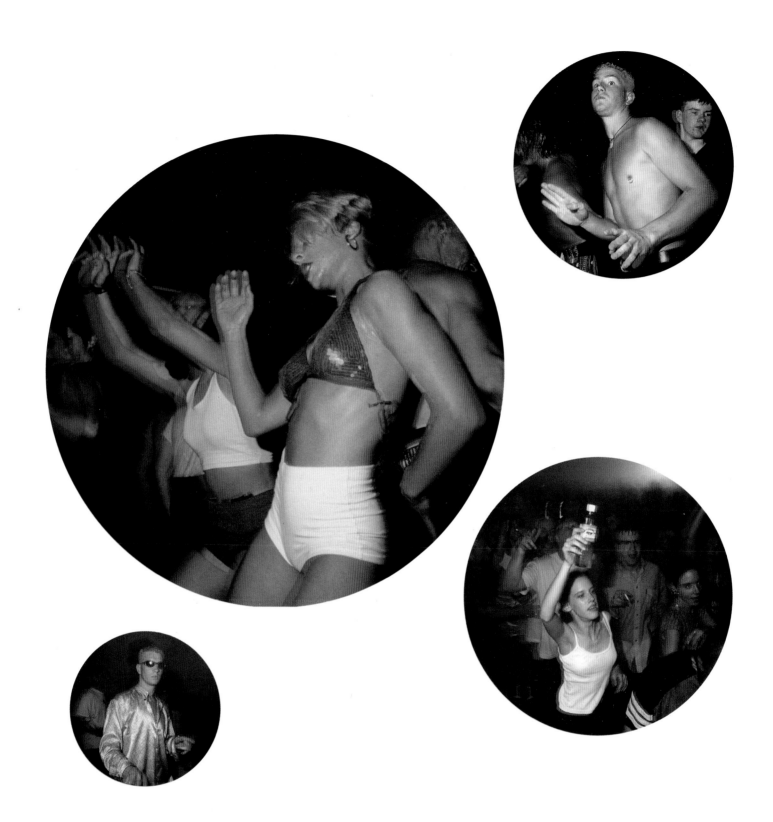

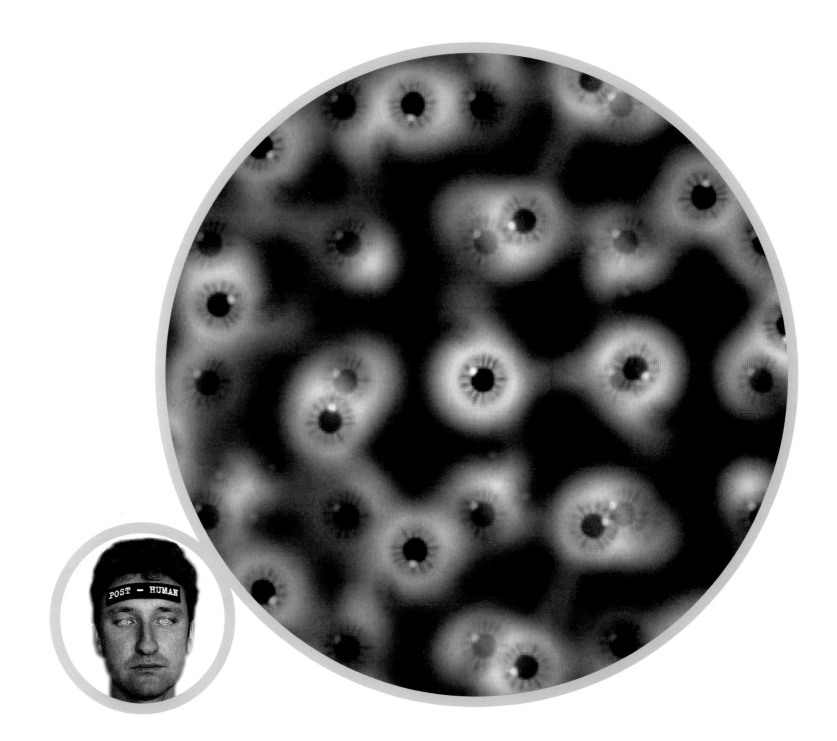

post-humanists are people who understand how the world is changing. by understanding this they are changing the world. surf or die. you can't control a wave, but you can ride it. complex machines are an emergent life form.

extracts from the post-humanist manifesto
by robert pepperell of hex

project:**interactive culture synthesiser** title:**synopticon** 1996
medium:still from interactive computer installation

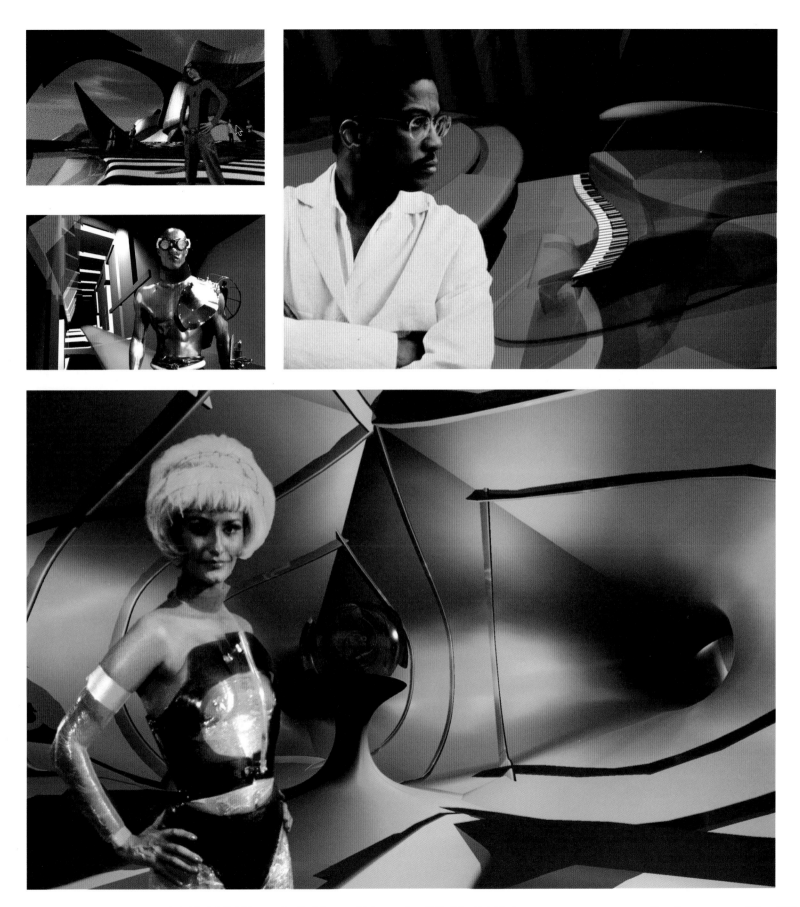

Q:how would you describe your work. A:virtual nightclub is an exploration into a completely surreal world, its stylised inhabitants and their music. an immersive, highly visual pop-culture artefact, with its own unique visual style.

project:**cd-rom game** design:**leo elstob**
title:**virtual nightclub** publisher:**philips media** 1996

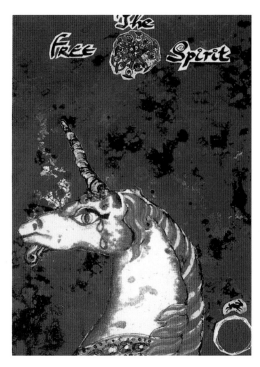

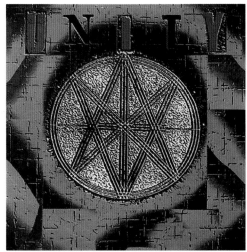

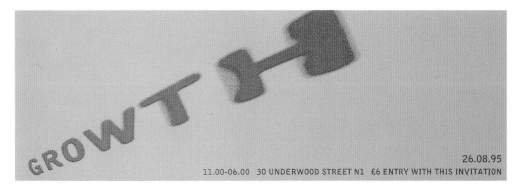

GROWTH

26.08.95
11.00-06.00 30 UNDERWOOD STREET N1 £6 ENTRY WITH THIS INVITATION

title:**oh so surreal** design:**pushca**
illustration:**deborah medhurst** title:**wigstock** design:**pushca**

title:**sabresonic 2** design:**madark**
courtesy:**matthew acornley**

title:**iconelastic** design:**outhaus productions**
courtesy:**matthew acornley**

title:**growth** concept:**30 underwood street gallery**
courtesy:**matthew acornley**

title:**free the spirit/unity/shamanarchy in the uk**
design:**jamie reid**

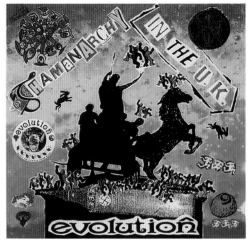

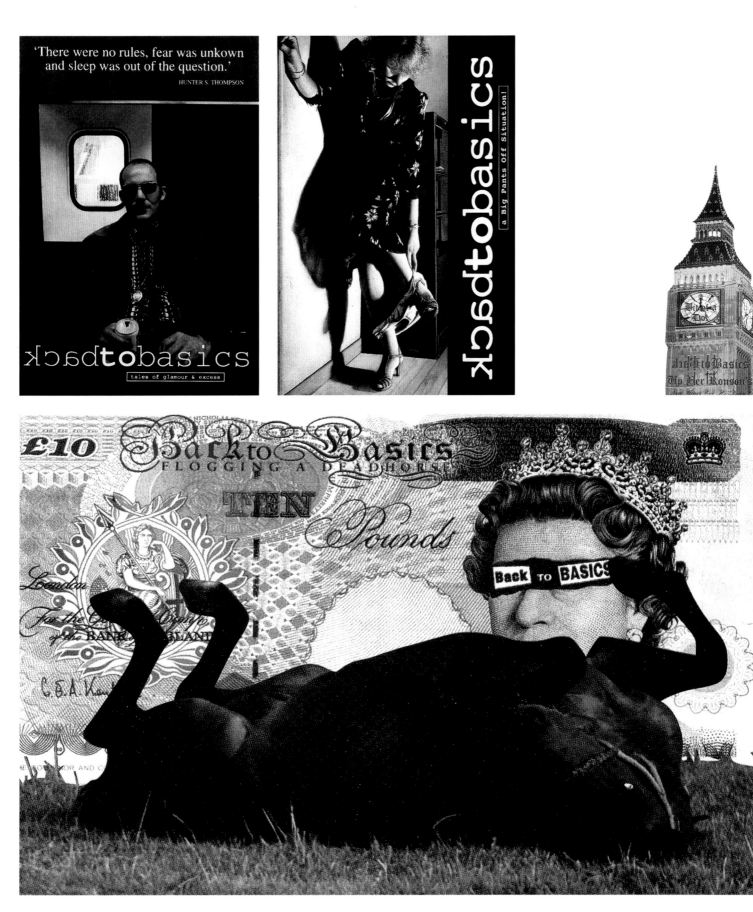

'There were no rules, fear was unkown and sleep was out of the question.'
HUNTER S. THOMPSON

backtobasics
tales of glamour & excese

backtobasics
a Big Pants Off Situation!

£10 Backto Basics
FLOGGING A DEADHORSE
TEN
Pounds

Back to BASICS

title:back to basics 135
design:dave beer at back to basics +
nick gundill at 5re design

fluff, fur and feathers

what i wear for out
something a bit tweedy a
eubank (simon foxton). i'd
ben sherman shirt and a pa
brad pitt (alexander mcque
i'll wear. my dream date is
(tomato). a clean t-shirt. i
girl and always likes a me
that i would wear shoes an
butch cassidy and the sund
likely to wear smiley face
hancock (antoni & al

A:

i am
not usually
preoccupied with
gs (hussein chalayan). i will probably wear
l my dream date would be the boxer, chris
ar what i always wear, my combat trousers,
of nikes. i would take jamie redknapp and
). ask my wife (captain 3d). fuck knows what
ny wife + my son (rankin). fox/guns 'n'roses
nk i'd bring my girlfriend, who's a smashing
ion (david sims). there is a strong chance
underwear, but not necessarily. dream date:
nce kid (sophie pendrell, anti-rom). we are
and our dream dates are yves klein and tony
on). a wig (donald milne).

gangsta
dj peshay

paperclip people
oscilator

Faze Action

iphonic

In The Trees

nu

header

title:**header #1** project:**enhanced cd 1996**
medium:**screen grabs**

Q:how would you describe your work A:keep a watchful eye watching and a wish wash wishling. and still I craved hindsight. now where they begin and end, music just sort of starts, runs all around and then stops.

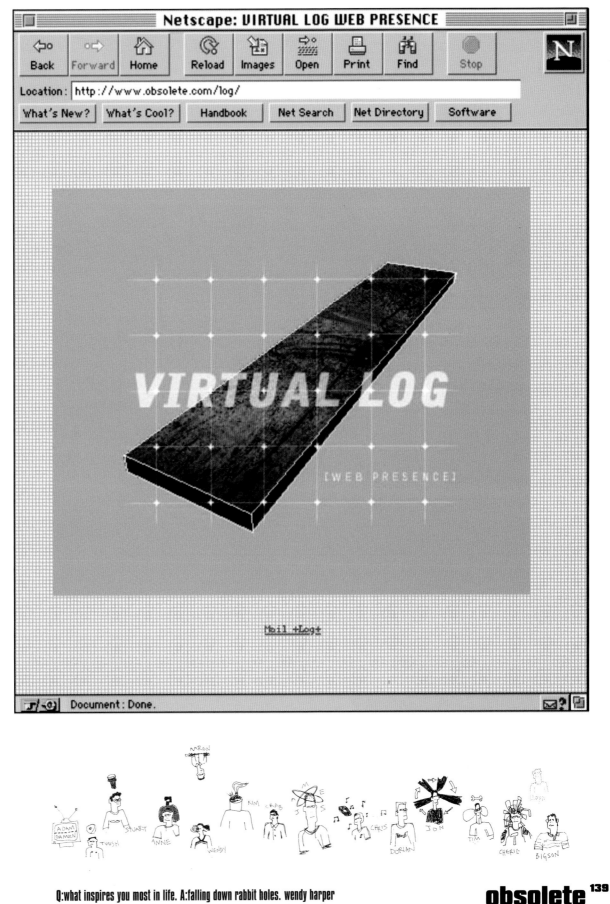

Q:what inspires you most in life. A:falling down rabbit holes. wendy harper

obsolete ¹³⁹

Q:how would you describe your work. A:time-based sculpture (nicolas). A:worklike (andy a). A:play (andy p). A:inconsistent (sophie p). A:small, hot and full of idiots (luke p). A:hard and long (tomas r). A:interactive (andrew). A:there's a little something for everyone (robert).

portrait:**jeremy murch** left to right:**sophie pendrell, luke pendrell, nicolas roope, tomas roope, andrew cameron, helen aver, andy allenson, robert le quesne, andy polaine**

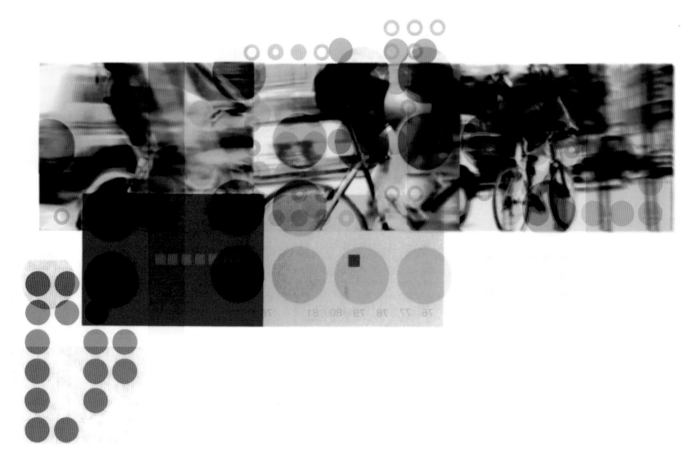

where i come from,
we eat jam for breakfast

exhibition organisation:**jane alison**, with lucy brettell
exhibition design:**tom dixon**, with yen-yen teh
audio-visual installation, design and consultancy:**simple**

photo credits:
all flat photography:**ferdy carrabott**
printer for mark borthwick:**robert man**
sponsors and printers for phil knott:**danny pope** at matchless print, **john** at johno's, **rob** at process supplies

acknowledgements: with thanks to all the following for their invaluable help and advice, and to **michael donlevy** for his inspiration and support.

ricki adar, emma atkinson, katy baggott, susie begg, isabella blow, sebastian boyle, laura buadaf, richard benson, judy blame, julie brown, cat callender, david crane, pete donne, helen griffiths, elein fleiss, rosie gentle, diana giorgiutti, emma greenhill, mark holgate, charlie holland, michael horsham, claire houlihan, louise kay, izzy king, kelly luchford, anne mccreary, neil mackay, samantha mclean, will mclean, michael maziere, suzy menkes, kate monckton, darryl moore, katie norbury, elaine palmer, peter ride, tamara salman, clinton silver, adam sodowick, jan stevens, vicki stewart, lee swillingham, alex thomas, stephanie tironelle, stephen turner, trino verkade, simon ward, charlotte wheeler, john wolford, olivier zahm.

urbanwear credits:
guerillawear:**mervyn rands**. komodo:**fraser trewick**. mickey brazil:**julie cuddihy+darren heslop**. hysteric glamour:**naoko kosuge+michael koppleman**. daniel poole:**beverley luckings, alan king+daniel poole**. maharishi:**brendon+hardy**. sign of the times:**sidone+vijay**. surge:**toby benjamin**. vexed generation:**joe, adam+matt**.

corporates members:
barclays bank of ghana ltd, kenya ltd, zambia limited and zimbabwe limited. the bethlem & maudsley nhs trust. british petroleum plc. the chase manhattan bank. robert fleming & co limited. save & prosper plc. sun alliance group. tsb group plc. unilever plc.

first published in the uk by barbican art gallery in association
with booth-clibborn editions 12 percy street london w1p 9fb
on the occasion of the exhibition:
JAM 12 september - 15 december 1996 at barbican art gallery
barbican centre london eC2y 8ds

isbn 1-861540-159

distributed world-wide and by direct mail through
internos books 12 percy street london w1p 9fb
printed and bound in the uk

barbican art gallery is owned, funded and managed by the
corporation of london
© 1996 barbican art gallery, corporation of london and the
authors and photographers